# THE GREAT DEBATE ABOUT ART

## Roy Harris

*Mum*. Avalon Harris Pepper (aged 3), 2000. Crayon on paper.

# The Great Debate About Art

Roy Harris

PRICKLY PARADIGM PRESS
CHICAGO

Prickly Paradigm Press, LLC
5629 South University Avenue
Chicago, Il 60637

www.prickly-paradigm.com

ISBN: 9780984201006
LCCN: 2010926527

Printed in the United States of America on acid-free paper.

# Contents

Preface ................................................................................i

1. Art for Art's Sake ....................................................1
2. Questions and Responses .......................................9
3. Art and Institutionalism .......................................15
4. Art and Idiocentrism............................................21
5. Art and Conceptualism ........................................29
6. Modernism and the Great Debate .......................35
7. Art and Anti-art ...................................................43
8. Art as Supercategory ...........................................55
9. The Art of "I Spy" ...............................................63
10. Art as Ambiguity.................................................77
11. Art Inside Out ....................................................85
12. In Defence of the Turner Prize .........................93
13. A Science of Art? ..............................................103

Envoi ...................................................................123

Notes ...................................................................127

References ...........................................................131

# Preface

What I call for convenience the "Great Debate about Art" is not just another in the seemingly endless series of partisan squabbles that have raged in the arts for the past two hundred years. These have been mainly over aims and techniques, dividing one school from another, this -ism from that -ism, all duly catalogued by the professional historians of the subject, who, simply by performing this function, implicitly include the controversial works and techniques as examples of art.

The "Great Debate" belongs on a different level: it concerns much deeper issues. These relate to the ultimate basis on which claims to establish any distinction at all between art and non-art are to be grounded.

Although it is a debate predominantly articulated in the domain of the visual arts, it has had an impact also on literature, music, dance and other forms of art. Surprisingly few of those who participate—

sometimes vociferously—in the Great Debate actually understand what it is about. Some mistakenly suppose it to be a controversy about matters of fact, i.e. about whether certain works in fact *are* works of art, or merely deceptions masquerading as art. Those who have seen what is wrong with this often leap to the opposite view and conclude that the Debate is not about art itself but only about the use of the word *art* by critics and theorists. But while it is true that works of art do not exist in a linguistic vacuum, the Debate is not—as it is sometimes said to be—"purely verbal."

By re-examining certain prominent episodes in the history of the Debate since 1800, I shall try to show that what are fundamentally at issue here are certain questions that have been overlooked both by the artists themselves and by art historians, literary critics and musicologists. These underlying questions are epistemological questions, and they relate to the limitations of human knowledge.

Such questions are rarely brought out into the open, but are obscured in various ways. The current social background to the Great Debate is one in which the general public is constantly being invited to admire "difficult" works which excite little or no spontaneous admiration on their own account; while "explanations" of these works are commonly couched in terms which, for most people, are virtually incomprehensible.

I shall argue that, viewed from an epistemological perspective, this curious history of the Great Debate about Art and the way it has been conducted provides the philosopher with important evidence concerning what can be known and how it is possible to know it; in other words, it throws light on how art fits into the total spectrum of human knowledge.

Readers will recognize frequent echoes of Dewey's fruitful conception of art as a "mode of knowledge." But Dewey was writing more than half a century ago, before the Great Debate had taken all the twists and turns that I propose to explore.

My thanks are due to John Carey and Tristan Palmer for comments on earlier versions of the text.

R.H.
*Oxford, October 2008*

# 1
# Art For Art's Sake

*L' art pour l' art et sans but; tout but dénature l' art.*
—Benjamin Constant

Topics of knowledge are as diverse as potential forms of human inquiry (knowing *that*, knowing *how*, knowing *what*, knowing *why*, etc.). Where does the question "What is a work of art?"—and its possible answers—fit in to this complex epistemological pattern?

The ambitious doctrine of "art for art's sake," first overtly stated in the 19th century, can be construed as an epistemological claim to the effect that the forms of knowledge involved in the creation and appreciation of a work of art are *sui generis*, and thus set artistic experience apart from all other forms of human experience.

All modern movements in the arts can trace their roots back to this doctrine. It was essentially a

modern doctrine, and would have made little sense to Renaissance artists such as Michelangelo or Leonardo, even less to the master-builders of the great medieval cathedrals, and none at all to the contemporaries of Julius Caesar or Alexander the Great. Without it, on the other hand, one can nowadays make little historical sense of fauvism, or futurism, or surrealism, to say nothing of latter-day "dematerialization" of the work of art. So it is with this doctrine that the Great Debate begins. It marks a watershed in the development of Western artistic consciousness—one of the few of which it can be said without exaggeration that the arts would "never be the same again."

Oddly enough, although snappily captured at the outset in Benjamin Constant's epigrammatic phrase "*l' art pour l' art*" in 1804, the doctrine was never provided with a coherent rationale, either by Constant himself or by its most ardent champions. Its critics seized on this lacuna to level all kinds of charges against it. Nietzsche dismissed the principle contemptuously as "a worm chewing its own tail" and proposed to paraphrase "Art for art's sake" as "Rather no purpose at all than a moral purpose." Proudhon called it "degrading" and declared it to be "vice in all its refinement, evil in its quintessence." Théophile Gautier, who came as near as anyone to producing a coherent case for it, allowed his defence to degenerate into ranting against "utilitarian" views of art. But this was a misdirected polemic; for the main opposition to art for art's sake would come not from utilitarians but from realists. Oscar Wilde, who rejected both realists and utilitarians ("All art is quite useless"), did not throw much light on the matter by insisting that "art never expresses anything but itself," since his pronouncements were widely interpreted as an

apology for elitism. Kandinsky added his own layer of mysticism to the confusion by explaining the emergence of the doctrine of art for art's sake as being due to the "bond between art and the soul" being "drugged into unconsciousness."

The strain of Romantic perfectionism that the doctrine parades needs no emphasis. Walter Benjamin called it a "theology of art" (*"une théologie de l' art."*) But its tacit appeal to purity and rejection of extrinsic values also allows it to be dismissed by Clark as "a myth designed to counter the insistent politicization of art." The goal envisaged, as with many Romantic projects, remained vague in the extreme. Marxists have always regarded it with deep suspicion: it was, according to Fischer, an "illusory attempt to break out single-handed from the capitalist bourgeois world and at the same time a confirmation of its principle of 'production for production's sake.'"

From the beginning, the trouble with the slogan *"l' art pour l' art"* had been its extreme vagueness. In one respect, that was its strength; it functioned as a rallying call to all artists who wanted to resist the notion that the rest of the world could tell them what they should be doing. But in another respect, that was its weakness; for it made it inevitable that there would be no consensus among artists either. It was a call to revolution which left no one quite sure what the revolutionaries were for or against. For a painter like Courbet, who had no doubts at all about the function of painting, the revolution was "pointless." It must also have seemed like that to many others who were less concerned with art or the arts in general than with their own particular artistic activities. In short, it made little or no difference to the working practices of many thousands of artists.

The weakest form of the doctrine of art for art's sake is strictly applicable only to those kinds of art in which a reasonably clear distinction can be drawn between "content" and "execution." Given that distinction, what the doctrine can be interpreted as saying is, roughly, that execution can be appreciated as art independently of content. This is a doctrine that even the most conservative of painters or writers could have made sense of, and even perhaps approved, at least if put in the shape of the following two propositions. One is that however banal or even unattractive the subject chosen may be, we recognize artistry in the handling of the medium. (Thus the art of the painter is revealed in such "painterly" qualities as composition, handling of colour, brushwork, mastery of perspective; that of the poet in expertise with words, etc.) The other proposition is that however important, beautiful, original and striking the subject chosen may be, that will not rescue it as a work of art if the skills of execution are poor. Thus expressed, the doctrine would be not merely defensible but uncontroversial, except perhaps to adherents to an extremely narrow view of art which attached supreme importance to *what* is represented, irrespective of *how*. In short, "art for art's sake" on this interpretation might perhaps be paraphrased as: "art resides in the technical excellence that the artist exhibits in the production of the art work."

One of the most uncompromising defences of the doctrine of art for art's sake came unexpectedly from the pen of E.M. Forster just after World War II. What is remarkable about it is not just the timing (given that the doctrine in question was hardly new and had been under discussion for more than a century). Even more remarkable is the interpretation Forster

offered of what the doctrine claimed. When Forster wrote his essay on the subject he was already well established as one of the major English novelists of his day. He delivered it as an address to the American Academy of Arts and Letters in New York in 1949 and reprinted it shortly afterwards in a volume of collected essays (*Two Cheers for Democracy*). So here we have a senior figure in the world of literature tackling, at the age of seventy, a controversial issue that he must have been familiar with and pondered at times throughout most of his working life as a writer. What did he make of it? And why did he think it necessary to take a public stand on it so late in the day?

Forster based his defence of the doctrine on the quasi-mystical claim that in the whole universe there are only two possible sources of "order" (or, as he sometimes puts it, of "Order"). One of these is "divine order" and the other is "esthetic order." This itself is a remarkable claim about human knowledge. Forster falls neatly into the category of those whom Dewey described as believing that art is "a mode knowledge superior not only to that of ordinary life but to that of science itself." For Forster, "social order" and "scientific order" are illusory. The work of art (his examples include *Antigone*, Shakespeare's *Macbeth* and Seurat's painting *La Grande Jatte*) is "the only material object in the universe which may possess internal harmony."

No attempt is made to justify this claim. But between the lines it is not difficult to detect that what Forster is anxious to oppose is what he calls "the implacable offensive of Science." Science, he alleges,

gave us the internal combustion engine, and before we had digested and assimilated it with terrible pains

into our social system, she harnessed the atom, and destroyed any new order that seemed to be evolving.

So-called "scientific knowledge" is, for Forster, a kind of Baconian "idol of the market." In order to understand what lies behind this detestation of Science, we have to go back to an essay Forster had written seven years earlier called "The duty of society to the artist." In this essay, Forster looks forward gloomily to the state of the arts in postwar Britain. He anticipated a postwar Britain in which the arts were increasingly dependent on state patronage in one form or another, but in which the state—in the persons of the bureaucrats responsible for subsidizing the arts—did not understand the *raison d' être* of the arts themselves.

Forster thus falls into line with those for whom the significance of the doctrine of art for art's sake was that of a creed emancipating the artist *qua* artist from all civic responsibilities and obligations. The issue was seen as being the relationship between society as a whole and a group of gifted specialists dedicated to pursuits that required public support if they were to flourish, but that did not necessarily make contributions directly relevant to perceived public needs. This is still a live issue today, in an era when public funding of many arts has become essential to their continued development. But it was still a long way off when Constant came up with his controversial dictum. Nor could he have foreseen the day when its Latinized version (*ars gratia artis*) would be hijacked by Hollywood and made the corporate motto of Metro-Goldwyn-Mayer.

Art for art's sake stands opposed to a basic assumption that goes back to ancient Greece and Rome.

In the Western tradition, the argument that the arts have a social responsibility originates with Plato and Aristotle. The widespread belief that Plato banished artists from his ideal state (repeated uncritically by some art historians, e.g. Gombrich, in "Illusion and Art") is based mainly on the misinterpretation of certain passages in the *Republic*. What Plato disapproved of were those poets who earned a living reciting tales of a kind that Plato considered immoral and not appropriate for the education of the young. He objected to the content of one kind of poetry rather than to poetry itself, just as one might nowadays deplore the poor quality and noxious influence of television programmes, but without thereby rejecting television as such.

For Aristotle, the arts exist in order to serve society; from which it follows that any arts or artists who do society a disservice are to be condemned. But the views of both Plato and Aristotle need to be understood against a background in which the arts (*technai*) include a much wider range of activities than would be taken to fall under that head in modern times. There was as yet no distinction between "sciences" and "arts." Throughout Graeco-Roman antiquity, the arts (Latin *artes*) include such diverse practices as shoemaking, navigation, poetry and warfare. For Cicero, agriculture and medicine are arts, no less than architecture. He has no conception of the "fine arts," as they would be understood from the 18th century onwards. The Romans divided the arts into "liberal" arts (*artes liberales*) and "base" arts (*artes sordidi*), the former comprising those worthy of being pursued by a free citizen and the latter including all the rest. That division from the outset was based overtly on social criteria and the social status accorded to certain occupations.

Classification of the arts took a more intellectual turn in the medieval universities. There the liberal arts were narrowed down to just seven: grammar, logic, rhetoric, arithmetic, geometry, astronomy and music. The Renaissance changed all that. By the middle of the 18th century, which saw the publication of that great monument of the French Enlightenment, the *Encyclopédie*, the roster of liberal arts was still limited to seven. Not the same seven, however, that the medieval universities had taught. The *Encyclopédie* lists them as: eloquence, poetry, music, painting, sculpture, architecture and engraving. Thus only two survive the whole way through from the age of Peter Abelard to the age of Voltaire: the arts of rhetoric (eloquence) and music. But Marmontel, Voltaire's younger contemporary who contributed the article *Art* to the 1776 Supplement to the *Encyclopédie*, still sees only two basic justifications for any of the arts: they must either be useful, or give pleasure, or both.

This is the background against which the intellectual thrust of the dictum *"l' art pour l' art"* must be measured. It proclaims, against the received wisdom of all previous ages, that no such justifications are necessary. Every art, every work of art, is its own justification. It seeks no further purpose. It submits to no higher judgment. These are the contentions that set the stage for the Great Debate.

# 2

# Questions and Responses

Art [is] the science of freedom.

—Joseph Beuys

"*L' art pour l' art*" sounds like—and is meant to sound like—a declaration of freedom or emancipation. Historians sometimes ask where it "came from." The formula turns up in one cryptic entry in Constant's diary, abandoned there like a new-born babe on a church doorstep. All we know from the entry is that Constant had been talking about Kant over dinner with the English writer Henry Crabb Robinson, and that Robinson was a follower of Schelling. If we turn to Schelling we can find, sure enough, many references to "art as such." But what Schelling meant by that is shrouded in the mists of German idealism. He tells us that art is "the representation of things as they are in themselves" and that the whole universe is a work of art "formed in God."

The fortunes of Constant's dictum in the 19th century derive in large measure from its orphan status. It is ready for adoption by any who are willing to give it a home and nurture it. And there were many foster parents ready to do that. It provided, in the first place, a general apologia for all artist-led innovations, particularly those which affronted established expectations of what a work of art "ought" to be or do. From impressionism to *art nouveau* and beyond, all "new" movements benefited from it. Constant's formula supplied the model for Picasso's description of early cubism as "painting for painting's sake." It could be read as standing in opposition to "art for tradition's sake," "art for the Establishment's sake" and "even art for the public's sake." It certainly was understood by many as standing in opposition to George Bernard Shaw's claim that "all great art cannot but be didactic." As far as the artists were concerned, it was often a licence to do as they pleased. It permanently wrongfooted conservatism in the arts by making all revolutionary artists judge and jury in their own case if it ever came to court. It created a climate of opinion in which progress in the arts came to be identified with trying something different, unconventional and—usually—shocking. It fostered the view that a never-ending search for new forms of expression was somehow endemic in the nature of art. That view still survives and flourishes in the postmodern period.

A quite different consequence was that the new doctrine sponsored inquiry into the ultimate psychological and physiological sources of art. This in due course opened the door wide to Freud and his followers. The reasoning was that if art is *sui generis*, that must be because it is based on the recognition of—and reaction to—certain archetypal features that are not necessarily

apparent on the surface. We see this already in Baudelaire: he points out how the coarse comedy of the grotesque differs from refined comedy of manners and draws a parallel between that difference and the way "the art-for-art's-sake school" differs from the "interested literary school." The suggestion is that the pursuit of art for art's sake leads to a search for the primal forms of art, as distinct from those more superficial manifestations overlaid by, and catering for, the fashionable demands of society.

Baudelaire's shrewd observation anticipates by several decades the fascination with African art that left such a mark on the studios of Paris. Attention began to be paid not only to the art of "primitive" peoples but to the art of children. The same idea can also be seen as motivating attempts to reduce visual composition to a basic inventory of shapes. (Cézanne thought that for painting Nature three were sufficient: cylinder, sphere and cone.) It contributed to the birth of abstract art (where abstraction is regarded as representing a more fundamental level of vision than conventional pictorial art). In this way understanding art comes to be equated with providing an analysis of its underlying forms of organization. It is here that the supposed "essence" of art is to be sought.

A third consequence derives from the very fact that the doctrine of art for art's sake came into the world without any accompanying fanfare of explanation. This sponsors the notion that perhaps explanation is unnecessary or even impossible. Taken to one extreme, the denial of the need for explanation becomes a denial of the legitimacy of asking "What is art?" Picasso once replied to that question: "If I knew, I should take good care not to tell." A generation or two

later we occasionally find artists of the postmodern era pathologically avoiding the word *art* altogether, presumably lest even using it should be seen as committing them implicitly to some definition. The notion that the essence of art cannot be put into words has obvious links with Wittgenstein's distinction between saying and showing. Combined, they yield the thesis that what art is can be *shown* but never *said*. There is no "outside" viewpoint from which it can be observed and described without falsification.

More important than any of the above was the fact that the doctrine forced both adherents and opponents to re-examine the fundamental question "What is art?" Art cannot be pursued, appreciated or cultivated "for its own sake" unless there is clarity about what art is. That clarity is also necessary, on the other hand, if the doctrine is to be denounced as misguided or worthless.

The doctrine of art for art's sake is reflected in many modern movements in the arts, ranging from the New Criticism in literature, T.S. Eliot's theory of "autotelic" function, along with Russian formalism, to the revival of "autonomous aesthetics" (Bohan Bujic) in musicology. But I shall not attempt to trace all these developments in detail.

I shall focus upon three well-documented positions that have become prominent in modern discussions of the arts. The first of these attempts to answer the question "What is art?" by relating it to the ways in which the arts are institutionalized in contemporary society. The second treats it as a question that individuals must answer for themselves, on a case-by-case basis. The third, more abstract than either of the first two, treats it as a conceptual question, which takes priority

over all matters of artistic execution. All three responses have far-reaching epistemological implications.

# 3

# Art and Institutionalism

> Works of art are art because of the position they
> occupy within an institutional context.
> —George Dickie

The so-called "institutional" view of art is associated in
particular with the work of two American theorists,
Arthur Danto and George Dickie. Institutionalism is
basically anti-essentialist. It does not admit any intrin-
sic criteria by which a work of art can be recognized.
According to Danto, "objects are works of art when the
artworld decrees them to be." This is what counts, not
the works "in themselves." According to Dickie, art is a
"conferred status," the status being conferred by "some
person or persons acting on behalf of a certain social
institution (the artworld)."

Both Danto's and Dickie's main interest is in the
visual arts, but the notion of an "artworld" can be

extended to any of the arts. Thus extended, the main claim is as follows: what counts as a work of art (painting, play, poem, sculpture, musical composition, etc.) is decided not by the artists themselves, nor by the general public, but by the institutions that exist to cater for society's needs and interests in these fields. Such institutions include museums, galleries, theatres, libraries, publishers, schools, academies, concert halls, exhibition centres, forms of patronage, art markets, specialist journals and the general press. Artists themselves rely on—and largely work through—such institutional channels, even when professing to be independent. What the institutional consensus approves and promotes as works of art, although sometimes controversial, is generally accepted by the rest of society because the curators, dealers, critics, patrons, teachers and historians involved are regarded as society's authoritative experts in such matters. In short, the recognition of works of art depends on informed opinion, this opinion being moulded and expressed through the views and activities of society's accredited arts institutions and their representatives.

One of the attractions of this theory is that it allows for various versions. There may be differences between rival theorists as to which types of institution play the leading role in determining what counts as art. The theorist may approve or disapprove of the institutions in question, or of their policies. (It is common to disapprove of the willingness of some collectors and museums to pay exorbitant sums of money for art objects at auction.) Tolstoy anticipated institutional theory when he complained about the rise of a professional class of art critics. (Why, he asked, do we need anyone whose job it is to tell us how to interpret or appreciate what artists do?)

Institutional theory can also be set up in a "weak" form and a "strong" form. In its weak form it says only that institutions are influential in guiding public taste. In its strong form it says that the institutions, collectively, *determine* what art is and what the arts are at any given time. The weak form is so anodyne as to arouse little disagreement. The strong form is intrinsically contentious. If either version is right, substantive conclusions appear to follow; for instance, that the relationship between the arts and society as a whole is quite different from that which obtains between the sciences and society as a whole. For individual scientists rely ultimately on fellow scientists to scrutinize, accept and validate their work as "science"; whereas, it would seem, individual artists cannot rely on other artists for any similar confirmation of the status of what they produce as "art." It falls to the institutions, not the artists, to deliver this verdict.

Thus if we wish to understand why some things are counted works of art and others are not, we should look not to the artists, their self-serving proclamations, their mutually flattering cliques and their judgments concerning their own work, but to the established institutions in the relevant artworld. We should inquire into how these institutions work, who runs them, and how they come to play the social role that they do.

Institutional theory clashes *prima facie* with one of the basic assumptions of the doctrine of art for art's sake. By demoting the artist to the status of mere producer of certain artifacts, the institutional theorist appears to imply that art is, after all, accountable to external criteria—criteria other than those of the artist. The work of art can in this way be treated like any other social commodity. The artist's output must sink or

swim in competition with the output of any other worker claiming recognition, attention and/or financial reward. All that is special about art is the existence of certain institutions which regulate, albeit in an informal and none-too-precise fashion, the recognition of a distinction between art and non-art.

Institutional theories are by no means confined to the arts. Institutionalism is a general *type* of theory. We can have institutional theories of religion, of law, of economics, of history and of society itself. One way of looking at what institutionalists claim is to see it as no more than one application of a more general sociological approach which assumes that society is just an interlocking set of institutions. So if the arts are to have any social recognition at all, it has to be by courtesy of certain institutions. Thus institutional theory emerges not as capturing a remarkable or surprising insight, but as a kind of truism. What differs between one society and another as regards the arts is that different societies have different institutions. But this is equally true of religion, law, etc. So the arts are no exception.

There is also a less obvious connexion between institutional theory and the doctrine of art for art's sake. Dickie's version of institutional theory began as an attempt to rebut the "ineffability" thesis; specifically, the claim made in the 1950s by a philosopher, Morris Weitz, that art is intrinsically undefinable. To this Dickie opposes his own view that, whatever art may be, it is no more undefinable than any other set of activities that people recognize and give a name to. Art is in this respect no different from trade, politics, work, entertainment, education, and so on.

Where does all this leave the doctrine of art for art's sake? It appears to force any serious defender of

that doctrine to choose between equally uncomfortable options. One option would be to compromise with the institutionalist and admit that, after all, artists do not have the final say in the matter, even though their work provides the basic material. But that retreat leaves some uncertainty hanging over what the artist's contribution to our perceptions of art actually is.

The other option would be to go on the offensive and challenge the role of the institutions. But that move is awkward and potentially self-defeating, since it is open to the obvious counterattack that what artists *say* art is commands no consensus even among artists themselves, while their actual work—if that is to be taken as demonstrating what art in practice *is*—turns out to be too diverse to be brought under any comprehensible order, except the order imposed by the institutions acting on society's behalf.

If institutional theory is right, it would seem that there is nothing to prevent collusion between institutions, or between influential individuals within institutions, or between particular artists and others in the relevant artworld, in imposing their own artistic preferences upon the general public. And that, according to some observers, is not just a possibility: it all too often happens. One example would be the alleged collusion between Bernard Berenson, at one time a leading authority on Italian Renaissance painting, and the art dealer Joseph (later Baron) Duveen. This partnership deliberately set out to enhance the reputation and value of certain art works and artists, for the financial benefit of both partners. A more recent example would be the Tate Gallery's appointment of certain favoured artists to its own board of trustees. This allegedly results in a situation whereby the favoured artists are in a position

to have the Tate purchase their own work and that of other artists represented by the same commercial galleries. It is commonly argued nowadays that the most powerful factors in the artworld are financial: collusion between artists, auction houses and investors conspires to achieve ends that are purely economic rather than serving the cause of art as such. Via this mechanism, "What is art?" becomes a question to which the answer is, at least in part, determined by the interests of big business.

More generally, it can hardly be denied that to the extent that any "artworld" operates as a closed system, with a very restricted number of institutions and individuals involved at any one time, ample opportunity is afforded not only for unscrupulous practices and mutual back-scratching but for the promotion of preferences that serve the purposes of the artworld itself, or of individuals in the artworld, rather than the purposes of art. A sceptic might say that the only thing wrong with the original "art for art's sake" doctrine was its failure to identify in whose hands it lay to determine what art is.

# 4

# Art and Idiocentrism

> To call something a work of art is to express a
> personal opinion.
>
> —John Carey

On the opposite side in the Great Debate about art
stands the idiocentric theorist. For the idiocentric theo-
rist what matters is the individual. John Carey, the most
articulate contemporary exponent of this view, tells us
in his book *What Good are the Arts?*:

> My answer to the question "What is a work of art?"
> is "A work of art is anything that anyone has ever
> considered a work of art, though it may be a work
> of art only for that one person." Further, the reasons
> for considering anything a work of art will be as
> various as the variety of human beings.

Or, put more succinctly: "Anything can be art, if we think it is." Carey does not shirk the implications of this theory in his own case, and explains at great length why he thinks literature superior to the other arts and what it is about literary works that he regards as having a particular claim on our attention as works of art.

Idiocentric theorizing has proved attractive to many in modern times, and the reason for its popularity is not hard to find. It gives every would-be artist the inalienable right to affirm his or her own works as "art," without waiting for the approval of any institution, or indeed of anybody else. At the same time, it gives the rest of us an equal right to withhold our approval, for whatever reason. Whether different individuals *agree* in regarding the same works as works of art thus becomes a matter of no great moment. In any case, there is no impartial way of adjudicating between them: art is something about which we must all make up our own minds.

That may seem at first sight to pre-empt all discussion. But not quite. Much depends on where the fundamental difference between idiocentrism and institutionalism is taken to lie. Carey sees the crucial difference between his own view and that of an institutionalist, such as Danto, as being a difference over whose opinion counts. He concurs with Danto that the criteria for being a work of art cannot reside "in the physical attributes of the object itself": what makes the object a work of art is "that someone thinks of it as a work of art." Where he disagrees is with Danto's contention that this "someone" must be a member of the artworld:

But no one, except the art-world, believes that any more. The art-world has lost its credibility. The electorate has extended, has, indeed, become universal.

Putting it in these terms makes it sound as if the institutionalist's mistake was to champion a theory that may once have been true, but has simply become, with the passage of time, out of date. But the difference between institutional and idiocentric theories is more profound than that. If the idiocentric theory is right, the institutional theory must have been wrong all along, and not just rendered obsolete by a change in the "electorate" or loss of faith in the institutions. For at the heart of idiocentric theory is the psychological notion that the effect of a work of art upon each of us is intrinsically private. We can try to describe it, discuss it, debate it, but we cannot voluntarily *share* it with others. Smith cannot give Jones his (Smith's) experience of a work of art, any more than Jones can have Smith's toothache.

Once that is accepted, institutional theory is exposed as committed to a cardinal error—the error of supposing that access to art can be accomplished by proxy. Whatever the artworld may decree in any particular case cannot simply be foisted on to society in general, without more ado, as a kind of collective artistic judgment. Why not? Because no member of the artworld has artistic experience that is valid for anyone else, not even a fellow member of the artworld. The credo at the core of idiocentric theory is that of Shaw's Saint Joan: "What other judgment can I judge by but my own?"

The dichotomy between idiocentric and institutional theory thus runs much deeper than across the arts.

Idiocentrism too is a general *type* of theory. As in the case of institutionalism, we can have idiocentric theories of religion, of law, of economics, and of society itself. Given any group, the idiocentric theorist will always try to reduce it to a set of individuals, acting as individuals, judging as individuals, believing as individuals.

Nevertheless, there is a tenuous thread stretching across that theoretical divide. It becomes visible at the point where the institutionalist needs to explain what the minimal conditions are for an institution to operate as an institution. Institutions are not monolithic and cannot be. Not all museums can show the same exhibits. Not all theatres can put on the same plays. Not all critics can review the same books or will have the same opinions about them. So the question arises—for the institutionalist—of determining at what point a work of art passes the institutional test.

If this question cannot be answered in any straightforward way, institutional theory risks collapsing into idiocentric theory. We see an example of this in the case of Dickie himself. He is driven to concede that many works of art are "seen only by one person," and that single person is their creator. (The painting was never exhibited, the book was never published, the play was never performed in a theatre.) So, it appears, creators may nevertheless be institutionally competent to confer the status of "art work" on their own creations. At this point it becomes difficult to detect any substantive difference between Dickie's position and Carey's. Dickie even admits that "every person who sees himself as a member of the artworld is thereby a member." The difference *might* be—but this is by no means clear—that Dickie intends us to understand a counterfactual subclause here: *if* others in the artworld

had also seen the work, they *would have* agreed that it counted as art. But this is another case of judgment by proxy. Carey—and idiocentric theorists in general—need resort to no such special pleading.

Carey's is not the only version of idiocentrism currently on offer. It is interesting to compare the arguments Carey presents in *What Good Are the Arts?* with those in David Lee's essay "What good is art?" Lee is using the term *art* in the much more restricted sense in which it is taken to apply principally to painting, sculpture and other visual arts. Many of his practical points could hardly be applied directly to music or drama. Nevertheless, if there is a case to be made out in favour of the arts in general, there must also be a case for each art in particular, and therefore a comparison between Carey and Lee should have something to tell us.

Lee is particularly scathing on those in government (and elsewhere) who believe that it is a "good thing"—i.e. somehow beneficial—to persuade as many people as possible, and of all ages, to visit museums and art galleries. He inveighs against the "misapprehension that art dispenses some sort of elixir," that there is some kind of "pick-me-up-medicine" or "feel-good drug that is art." He holds that there are indeed magic moments that could come in no other way than through the contemplation of art, but that they are far and few between, unguaranteeable, and forever beyond the reach of most of the population. He cites one such moment in his own experience on a visit to the Tiepolo frescoes in the Villa Valmarana near Vicenza. But to go tramping around museums in search of such moments would be a waste of anyone's time. Lee says:

Quite what anyone hopes to gain from breezing through half a dozen civilisations in the British Museum in a couple of hours is anyone's guess. The truth is that many of those millions of weary visitors don't achieve half what they might because they haven't been told that effort is required.

He recommends that authorities face the fact that "a majority of the population is thick, passive and bone idle and stop pretending that galleries and museums are for those other than specialists and devoted art lovers."

According to Lee, serious engagement with art is hard work, requiring time and dedication that many people cannot afford to give. What we get out of a work of art depends on what we have put into coming to appreciate it. He describes, for example, how long it took him to realize from studying the fragmentary sculptures of the Parthenon that there is no stylistic uniformity and that some of the sculptors who worked on that masterpiece were much better than others. Thus, from the detailed study of one work, it is occasionally possible to arrive at a general truth about art; in this case, that in a single project on which many artists have worked, there will inevitably be variations in quality.

It is possible to see how Lee's arguments can, in general, be applied to any of the arts, although Lee himself makes no attempt at this generalization. The details of the "hard work" that is necessary would vary according to the specific requirements of the art in question. Those whose passion is painting have no need to educate their ear, while those whose passion is music can afford to be as blind as a bat. But whatever

the field selected, some analogue of Lee's case could presumably be put forward.

Much of what Lee writes about art and the general public will sound elitist to many readers. But that would be to misjudge it. If we follow his argument through, it is actually an apologia for idiocentrism, not elitism. For it follows from what Lee says that none of us has the time available to put in the necessary work on all the arts, or even to study a single art in the same depth as the specialist. Inevitably, therefore, artistic experience must vary from one person to the next, and only the individual is ever in a position to answer the question "What is a work of art (for me)?"

# 5

# Art and Conceptualism

The work is beyond direct perceptual experience.
—Douglas Huebler

Another answer to the question "What is a work of art?" claims that the artist does not need to produce a painting, a poem, a symphony or a piece of sculpture at all; because the art work resides in the *idea*. This is the theoretical basis of "conceptual art." The entire manifesto of conceptualism is sometimes thought to be contained in Sol LeWitt's oracular pronouncement of 1969: "Ideas alone can be works of art." But that is ambiguous. Does it mean that *only* ideas qualify as works of art? Or just that one subclass of works of art is the subclass comprising certain (artistic) ideas?

Whichever interpretation we take, the underlying rationale seems to rest on a realization that it is meaningless to keep mouthing the mantra of "art for

art's sake" unless someone can define what actually constitutes a work of art. By peeling off successive layers of inessential attributes, the analysis supposedly progresses to the point of revealing that, at the very centre, all that may remain of a work of art is a concept. This is the ultimate *sine qua non*. No concept: no art.

Conceptualism has in common with institutionalism a refusal to accept that being a work of art depends on the physical characteristics that the work exhibits. This has not prevented some conceptual artists from adopting an overtly disgruntled anti-institutional rhetoric. Others, however, have profited greatly from having their cause taken up and their work promoted by prestigious museums and galleries. It is therefore difficult to characterize conceptualism as being opposed to institutional theory in principle. There is, after all, no reason why institutions should not disseminate ideas.

Dematerializing the art object opens the door to such paradoxical enterprises as art exhibitions in which there are no exhibits (the most celebrated example being Robert Barry's exhibition in Amsterdam in 1969, where there were no works on view). Although some of its more enthusiastic protagonists regard conceptualism as an unprecedented breakthrough in thinking about the arts, its intellectual content is no advance on the theory that flourished earlier in the 20th century under the label of "idealism." R.G. Collingwood, one of its foremost advocates in philosophy of art, stated the basic premise as follows: "Art is the primary and fundamental activity of the mind, the original soil out of which all other activities grow." Art thus takes priority over philosophy, religion and other forms of thinking. Given this, the "externalization" of art in any tangible form

plays a secondary role. It is both a pragmatic misapprehension and a logical mistake to equate the resultant *artifact* with the *work of art* itself. The two are different and the former is only a "representation" of the latter. The artifact is a particular object that may deteriorate or be destroyed, whereas the work of art is sempiternal and imperishable—something approximating a Platonic Form or Idea.

Idealism, however, was always open to the objection that the account it provides is an account not of art but of creative thinking in general. Does every creative process result in a work of art? This seems doubtful and would in any case require further argument. The basic problem with conceptualism in its most radical form is exposed as soon as someone asks the question "How does the artist express and communicate these dematerialized ideas that constitute art?" At least one conceptual artist tried telepathy; but that never caught on (the reason being, according to sceptics, that telepathic works of art were difficult to sell). For a society that does not believe in telepathy, the assumption has to be that *some* physical mode of expression is necessary. Even if the self-centred artist is a monomaniac concerned with no one else, the retreat to "pure ideas" risks being a retreat into vacuity.

Conceptualism often sounds like a badly digested dose of Hegel. "Badly digested" because it ignores Hegel's careful distinction between concept (*Begriff*) and idea (*Idee*). Thus we pass rapidly from philosophy of art to hocus-pocus, of which there are various levels in conceptualist theorizing. At the top level, its internal contradictions are recognized, embraced and celebrated triumphantly as a form of irrationalism. On this level we find LeWitt's claim that

"conceptual artists are mystics" rubbing shoulders with Sir Nicholas Serota's contention that the appreciation of conceptual art is akin to a form of religious experience. (This is as rampant as neo-Platonism gets in the modern artworld.) The next level down is occupied by those who would like to retain some semblance of a connexion with common sense and define conceptual art accordingly as "work in which the idea is paramount and the material form is secondary." Which would be fine, if anyone could tell which part of the work is "idea" and which part is "material form." (How does Michelangelo's *David* rate here? If the statue were destroyed, would the "idea" survive? What would that survival consist in?) The bottom level is occupied by those who are content to insist that there is a distinction between the original idea and its material execution—a distinction which clearly has its basis in the banal fact that a work of art may be made by a person or persons other than its designer. (This was always the case traditionally in the theatre, music and architecture.) On none of these levels except the last does conceptualism carry much conviction. Even here one may ask, for example, whether the performance of a symphony has not as much right to be considered a work of art as the symphony "itself" (however that might be defined).

Does conceptualism too, like institutionalism and idiocentrism, represent a *type* of theorizing? The answer is "yes." Perhaps its most perspicuous application is in the realm of politics. Defenders of democracy, for example, remain unmoved by the objection that in practice there has never been a fully democratic state, and that the translation of democratic principles into actual forms of government is invariably flawed. When they defend democracy, they are defending an idea.

(There may be conflicting views of what the idea is, or of how it may best be translated into political practice, but those are further questions.)

Where all forms of conceptualist theory strain credibility—in politics, art, or any other domain—is at the point where their defenders claim that the concept alone, in abstraction from any material realization, is all that matters. However, what strains credibility—I would like to suggest—may become interesting in certain circumstances. What circumstances? Circumstances in which what began as seemingly implausible ceases to be so. The classic example from modern visual art is the readymade. Marcel Duchamp's urinal seemed an implausible work of art when first submitted for exhibition in 1917. It may still seem so to some people today, but their numbers must be diminishing, because over the years it has become absorbed into the history of Western art and recognized as a turning point: a turning point, precisely, in ideas about what art is. The episode can be construed as the counterpart to a deliberate scientific experiment, designed to answer the question "What if a totally unlikely artifact were to be proposed as a work of art?" The answer seems clear: it *may*—eventually—come to be accepted. Not because the urinal is no longer a urinal, but because the whole conceptual framework within which it appears has changed. This comes as close to an empirical demonstration of the validity of conceptualism as we are likely to find.

# 6

# Modernism and the Great Debate

Western civilization is not the first to turn around and question its own foundations, but it is the civilization that has gone furthest in doing so.
—Clement Greenberg

Today the Great Debate about Art is mainly conducted under the auspices of the three types of theory outlined above. That triangular forum (institutionalism vs. idiocentrism vs. conceptualism) is what distinguishes the modern shape of the Debate from earlier versions. In earlier times, other theories were paramount; including the theory that art is an imitation of Nature, and the theory that art is the expression of Beauty. It would be an oversimplification to say that no one any longer believes that art is an imitation of Nature, or that art is the expression of Beauty. But these theories, although of historical interest, no longer play the role they once

did in staking out the ground over which controversy rages. The Great Debate has moved on. Notions like "Nature" and "Beauty," where they are relevant at all, are relevant in a different way.

It is impossible, for example, to imagine any artist or critic of the 18th or 19th centuries writing about beauty in the way the French artist Jean Dubuffet does after the Second World War. He sees the traditional Western idea of beauty as "completely false," an invention of Greek philosophers:

> I find this idea of beauty a meager and not very ingenious invention, and especially not very encouraging for man. It is distressing to think about people deprived of beauty because they have not a straight nose, or are too corpulent, or too old. I find even this idea that the world we live in is made up of ninety per cent ugly things and ugly places, while things and places endowed with beauty are very rare and very difficult to meet, I must say, I find this idea not very exciting. It seems to me that Western man will not suffer a great loss if it loses this idea. On the contrary, if he becomes aware that there is no ugly object or ugly person in this world, and that any object of the world is able to become for any man a way of fascination and illumination, he will have made a good catch. I think such an idea will enrich life more than the Greek idea of beauty.

Similarly, it is difficult to imagine any artist of an earlier period who was committed to the idea of art as an imitation of Nature pursuing this fascination with natural processes to the extent exemplified in Damien Hirst's *A Thousand Years* (1991). There, in a

large glass case, we see a rotting cow's head, off which live maggots and flies are feeding.

Whatever we may think of the ideas of Dubuffet or Hirst, and regardless of whether we accept their work as art or not, it is hardly open to doubt that the issues they raise could never have been debated a hundred years earlier. What explains this shift in focus? In his book *The Intellectuals and the Masses*, Carey argues that the decisive factor was the upheaval brought about in Europe by the introduction of universal education in the 19th century. This quite unprecedented social development threatened the status of the European intellectual, which had traditionally been founded on the very education that hitherto the general populace had been denied. The reaction of the intellectuals was to try to distance themselves from the newly enfranchised beneficiaries of state education. Artists too wanted to be recognized as intellectuals, not just as producers of artifacts. They resorted to cultivating difficulty and obscurity in all the arts. We find poets abandoning regular verse forms, novelists forsaking traditional narrative, painters painting crudely distorted pictures, musicians composing tuneless pieces of music and dancers rejecting the constraints of traditional ballet. All classical models were flouted or ignored. One controversy followed another. Thus a major crisis was provoked in the arts, the result of which was to put the arts once again—as they had been for generations past—beyond the intellectual reach of the *hoi polloi*. This crisis and its aftermath came to be known as "modernism."

It is typical of modernist (and postmodernist) art that its manifestations require theoretical explanations in esoteric terms that only intellectuals are familiar with. This became routine with the iconoclastic work

produced in the studios of Montmartre before and after World War I. The same phenomenon can be observed today when draping a bandage round a public building is claimed to be a work of art, or a pile of bricks on the gallery floor is presented as a piece of sculpture. Such work commonly invites and evokes copious commentary purporting to explain what the work "means" and why.

Futurism was the modernist movement that most stridently acclaimed the impact of science on traditional views of art. Atkins aptly sums up the Futurist approach as "ecstatically attuned to the brave new world of the recently invented automobile, airplane and cinema." Its aesthetic was epitomized in Marinetti's famous pronouncement that "a roaring motorcar... is more beautiful than the Victory of Samothrace." Marinetti advocated the destruction of all museums and libraries, everything that perpetuated reverence for the art of the past. According to Umbro Apollonio, one of the influences on the Futurists was Maxime du Camp's *Chants modernes* (1855), "which was really a hymn to science and an attack on the ideals of Greek beauty." The *Manifesto of Futurist Painters* (1910), signed by Boccioni, Carrà, Russolo, Balla and Severino, proclaimed that "the triumphant progress of science makes profound changes in humanity inevitable." One of these inevitable changes was a revolution in humanity's conception of art. The same manifesto exhorts its readers to "rebel against the tyranny of words" and to rejoice in "a world which is going to be continually and splendidly transformed by victorious Science."

In a later manifesto, published in 1913, Marinetti declared: "Futurism is grounded in the complete renewal of human sensibility brought about by the great discoveries of science."

No one would claim that universal education and the reaction of the intellectuals to it were the only factors contributing to modernism. But that they were major factors seems to be confirmed by two independent pieces of evidence. One is the early history of photography. The hostility that photography initially encountered from traditional painters, their patrons and the art critics had to do not merely with the fact that the camera was a machine, but with its being a cheap machine that anyone could buy and use without special training. Thus, almost overnight, there arrived on the scene a newly licensed mob of image-makers who had never been to art school. This was roughly the counterpart in the visual arts to the newly literate social stratum of readers with access to literature. In many cases they were the very same people and both groups were despised by the intellectuals. Photography, allegedly, was too "easy" to be a genuine art form: anyone could do it. Félix Nadar claimed in 1857 that the theory of photography could be learnt in an hour and the practical rudiments in a day. As for the actual operations involved, said Nadar, they could be mastered "even by the most dimwitted." Just the art form for lumpendemocracies.

The other piece of evidence comes from comparative anthropology. If we compare what happened in Europe to what was happening in other parts of the world in the 19th century, we find that in China, India and other countries where there was no educational programme of mass literacy, there was no sudden advent of modernism either. These were also countries where people were still living a life largely unaffected by the Industrial Revolution and its accompanying technologies. They were countries in which science had not yet emerged as a supercategory to be

reckoned with. The arts continued undisturbed on their traditional course, and their practitioners evinced no desire to challenge those traditions.

Modernism, therefore, is best seen as the joint product not only of universal education, which expanded the horizons of the majority of the population, but of the simultaneous struggle for cultural hegemony between arts and sciences. Art now stood in need of justifications that would have seemed superfluous in an earlier age.

That may perhaps explain the whiff of evasiveness about some of the claims put forward in the Great Debate. The circularity of definitions is sometimes admitted even by their advocates. Dickie, for instance, concedes that his own institutional definition of art is circular, but maintains that "it is not viciously so." It escapes that more serious charge, in his view, because he has backed it up with a great deal of information about the artworld and how it operates.

But is this enough to let the institutionalist off the hook altogether? The problem is that society has many kinds of institutions. What is by no means clear is *which* of those institutions are engaged in—and by—the institutional definition of art. If we cannot tell which institutions are thus engaged and which are not, then the difficulty of defining works of art is not resolved but deferred: it arises again straight away at one remove as a difficulty in classifying institutions.

According to Dickie, it is possible that the same exhibit might be shown at the Chicago Art Institute and at the Chicago Field Museum of Natural History. Its standing as a work of art would vary accordingly: "one institutional setting is congenial to conferring the status of art and the other is not." But Dickie offers no

evidence to indicate that anything shown at the Chicago Field Museum of Natural History *cannot* be considered—when and as exhibited there—to be a work of art. On entering a natural history museum, visitors do not make a tacit undertaking to view the exhibits *only* as specimens of natural history.

A similar problem for the institutionalist is the case of pottery. It may be marketed as "art" by galleries calling themselves "art galleries." It may also be marketed as "craft" by galleries calling themselves "craft galleries." Thirdly, it may be marketed by high-street retailers who draw no overt distinction between arts and crafts. Nor is the difficulty resolved by invoking the fact that nowadays certain kinds of pottery may sometimes be explicitly described as "art pottery." For exactly the same objects may be exhibited at another venue as examples of ceramic craftsmanship. Similar considerations apply in such fields as furniture-making, weaving, glass-blowing and many more. The distinction between arts and crafts has been a perennial bone of contention at least since the days of William Morris and is often acrimoniously disputed by those who see a question of professional status at stake. To avoid controversy, a landmark exhibition at the Victoria & Albert museum in 1973 had to be entitled, with deliberate ambivalence, "The Craftsman's Art." There is no "institutional" solution to the problem: on the contrary, the institutions in their present-day Western form exacerbate it.

A comparable difficulty arises within the idiocentric theory of art. As Richard Wollheim points out, to say that a work of art is by definition an object that we are disposed to regard as a work of art is to invite the charge of circularity: "for the *definiendum* reappears in the *definiens*, moreover in a way which does not allow of

elimination." If we say that a work of art is anything that anyone has ever been disposed to regard as one, we have still said nothing about what regarding it *as art* involves. The definition itself does not say how to proceed in order to determine what kind of "regard" that is. If *everyone* is entitled to have a say in the matter, any hope of obtaining a clear answer rapidly disappears. It leaves a vast research programme—i.e. investigating millions of individual opinions—but proposes no methodology for tackling it. Even if this is not strict circularity, it is another indefinite deferral of the problem.

The conceptual theory of art fares no better here. The proposition that ideas alone can be works of art presumably does not imply that *every* idea is a work-of-art idea. So unless we know how to distinguish those ideas that are works of art from those that are not, we appear to be no further forward. Is Mary's idea for decorating the bathroom a work of art—irrespective of how the decoration is executed in the event? It would be no contradiction for the conceptualist to maintain that Mary's idea was a work of art even though the actual decoration turned out to be a botched home-handyman job. This is in line with the conceptualist's refusal to equate the work of art with its execution. But what the conceptualist has not yet done is supply any criterion for deciding the status of Mary's idea. It cannot just be left to Mary to decide; for then conceptualism merges into idiocentrism.

Thus the institutionalist, the idiocentrist and the conceptualist can all three be accused of begging the question, although in different ways. The result has often been to reduce the Great Debate to a dialogue of the deaf.

# 7

# Art and Anti-art

> What we are celebrating is at the same time a
> buffoonery and a requiem mass.
>
> —Hugo Ball

No orthodoxy is fully mature until it starts to breed
heresies. In the case of art, it took a hundred years and
the provocation provided by a world war before the
doctrine of art for art's sake finally generated its own
heresy: the heresy was called "Dada." It was often
misunderstood as a protest against Establishment art,
but it was much more than that. It often sounded like
political dissent and a rejection of the bourgeois state,
but it was more than that too.

The Dadaists went further than their Futurist
predecessors. The Futurists did not wish to deny the
possibility of art in the modern world: on the contrary,
as Carlo Carrà claimed in 1915, "It is only with [the]
Futurists that true ART will be born."

The terms most often used today in describing Dada include *shock*, *outrage*, *revolt*, *disillusionment*, *nihilism* and *absurdity*. Of these the last is probably the most significant. In the hands of the Dada artist, absurdity moves from being one of the non-desiderata in art to an aesthetic creed in its own right. It was the cult of absurdity that swept the work of a small and relatively undistinguished group into being a major cultural event. Although the original Dada movement was short-lived, the exploitation of absurdity in art long survived it, notably in the stories of Franz Kafka, and, for a much later generation, a whole "theatre of the absurd" in the years following World War II.

The absurd has a variety of manifestations. Absurdity may be generated, in the first place, by a deliberate mismatch between the work and its title. The paradigm example is the title Duchamp gave to his urinal, "Fontaine." This gimmick long outlived its original purpose. In 1991 a darling of the conceptualists, Damien Hirst, exhibited the corpse of a tiger shark floating in a tank in a formaldehyde solution and called it "The Physical Impossibility of Death in the Mind of Someone Living." In 1920 this would have been regarded as a typical piece of Dada mischief. But by the end of the 20th century the principal function of arts-peak had become that of legitimizing with po-faced solemnity whatever extravagances the current avant-garde might produce. So we find the anonymous author of the Royal Academy guide to the *Sensation* exhibition (1997) struggling to "explain" Hirst's shark as "the absolute manifestation of fear, death and the unknown." Here the wheel has come full circle in the Great Debate: the absurdity of the title is now matched only by the absurdity of the official explanation.

A different source of absurdity is deliberate internal contradiction in the work itself. Here the classic example is Man Ray's flatiron with a row of nails protruding from the smooth surface. Another is Duchamp's bicycle-wheel sculpture of 1913, in which a single bicycle wheel has been solemnly mounted on top of a wooden stool. This kind of absurdity has no need of support from words: it is inherent in the conflict between form and function.

A third source of absurdity is the verbal nonsense expressed in statements about Dada. According to Dawn Ades, "Dada works have their only real existence as gestures, public statements of provocation." The first Dada manifesto of 1916 (proclaimed in neutral Switzerland on Bastille Day, the traditional celebration of the French Revolution) admitted:

> DADA remains within the framework of European weaknesses, it's still shit, but from now on we want to shit in different colours so as to adorn the zoo of art with all the flags of all the consulates.

Here there is a suggestion that continuity with the past is perhaps inevitable, even if it is no more than an excremental continuity. But in the second, more detailed manifesto of 1918, the full extent of the rupture with the past is revealed. After a playful flirtation with various theories of art in succession, including idiocentrism ("everyone makes art in his own way"), the truth is at last proclaimed: "We don't accept any theories." And that means: *any* theories, including art for art's sake.

Out with the theories go the old definitions and the old language. This becomes clear in the third manifesto of 1919, where the word *art* itself is described by

Tzara as "a parrot word—replaced by DADA, PLESIOSAURUS, or handkerchief." A parrot word is mere sound without meaning. Accordingly Dada poets composed "phonetic" poems, sequences of mere sounds, the predecessors of what was later called "concrete poetry." These were sometimes construed as bold innovations in poetics; but they were the very opposite. They dismantled poetry by refusing it meaning.

The deliberate absurdity of Dada must not be confused with the absurdity to be found in countless examples of the overblown bombast that has become par for the course in art criticism. The pretentiousness of bad art writing has now been part of the staple diet of the satirist for at least a generation. Richard Ingrams' original collection in *Private Eye's Book of Pseuds* (1973) included such examples as the critic in the *New Statesman* who enthused over a Beatles album "in which lyrical pentatonic innocence is modified but not destroyed by rhythmic ellipsis or harmonic ambiguity," and the art exhibition of crashed cars, described as "sculptures," each of which is "a memorial to a unique collision between man and his technology." Then there was the columnist who confidently interpreted the dead parrot in the famous Monty Python sketch as a "metaphor for God." Literary criticism did not escape either: one distinguished academic scored a bull's-eye on the pseudospeak board with his *Sunday Times* account of Samuel Beckett's punctuation ("His full-stops, daunting but undaunted, take up all his time and space...").

The prize collection is to be found in David Lee's column "Artbollocks," which has now been running for several years. In 2008 it included such gems as the following extract from a description of an exhibition at the Centre for Contemporary Art in Moscow:

Liquid Room is an exciting show of video-art, a form of art which is also itself a kind of liquid architecture, very close to the fluidity, transparency and vagueness of the inner life. Our post-literary age, already fascinated by the "liquid architecture in cyberspace" (Marcos Novak), liquid identities and everyday liquid contacts between people, is focused on lightweight infrastructure in motion, the "musical" structures of light, sound and colours, the ability to transform visual arts into urbanism shows or the real need to sense the reality as a fluid network of individuals, art and technology.

This example is notable for a growing tendency among writers of artbollocks to quote other writers of the same jargon, in the attempt to lend a spurious self-supporting authenticity to the edifice of verbal absurdity thus constructed.

It is curious that James Elkins in *What Happened to Art Criticism?* fails to recognize or comment upon the phenomenon of artbollocks, even though some of the critics he discusses are masters of that particular idiom. Although artspeak fatuities often sound much alike, they come in different varieties. The differences are superficially disguised by the level of fatuity itself. Like oncoming car headlights, the glare of absurdity blinds one to what lies behind it.

There is an important difference between the absurdity of a proposition and the absurdity of the language in which it is expressed. Keats' "Beauty is truth, truth beauty" is an absurd proposition, regardless of its merits as a line of poetry, and there is no paraphrase that can disguise that absurdity. But Oscar Wilde's dictum "Art never expresses anything but

itself" is an absurd way of putting a proposition that, although debatable, is far from absurd; namely, that a work of art should be judged by its artistic value, and not by any other criteria.

In the visual arts, the rot set in with the rise of art journalism as a profession during the 19th century. This is where the history of artbollocks begins. Art journalism provided a forum for debate, and cliques dedicated to promoting the cause of one particular artist or school. The journalist became a partisan who needed an inexhaustible vocabulary of praise and blame as a matter of professional necessity. In these conditions, what were once serious terms of artistic appraisal degenerate into clichés. Signs of lexical desperation soon become apparent. Even Baudelaire, in his art journalism, is driven to inventing such grotesque distinctions as that between *surnaturalisme* and *antisurnaturalisme* (in order to explain how the painting of Ingres differs from the painting of Delacroix).

Concurrently with the rise of art journalese comes the development of an unholy alliance between the art historian and the art dealer. This reached its climax in the late 19th and early 20th centuries, with the arrival on the scene of flocks of rich American collectors and institutions, prepared to spend unprecedented sums on looting Europe of its art treasures.

That change in the market brought with it a new challenge: how to talk about art in terms that will persuade the "hard-headed" philistines to part with their dollars. The first person to master the new patter showed his skill by making a fortune out of it. He became the first artspeak millionaire: Bernard Berenson. Berenson had a very sharp eye, allied to an amazing visual memory for detail. But even more important was

his gift of the gab. One of his business associates, Joe Duveen, is reported as having said of Berenson: "He could write the Book of Genesis if he tried, but that doesn't mean he believes a word of it." In practice it did not much matter whether Berenson believed what he proclaimed: what mattered was that his clients did. It would be difficult to find an art book which contains more piffle per paragraph than Berenson's *Aesthetics and History*. Open any page and you will find such choice specimens as "Ideated sensations... are those that exist only in imagination, and are produced by the capacity of the object to make us realize its entity and live its life"; or

> The work of art serves not only as a joy for all time, seeing that it offers permanent possibilities of life-enhancement, but from the moment of its completion, for generations to come, it serves as a model, after which the society in whose midst it has appeared tends through its most sensitive members to shape itself.

The art journalists who were contemporaries of Baudelaire never hesitated to display their own *parti pris*, but Berenson cloaked his sales talk in a kind of pious solemnity that passed for impartiality. His expertise purported to be based on being able to detect artistic authenticity—an essential commodity for well-heeled buyers who lacked any sense of what was genuine. So Berenson's carefully honed artspeak had to serve a dual purpose. It was necessary to persuade the clientele not only that Berenson knew what he was talking about but that they too could begin to understand what that was.

But not understand *too* much. There must remain a mystic aura surrounding great art. (Why would it be worth all that money otherwise?) Hence Berenson opts to deal in abstractions that sound vaguely comprehensible but are never exactly defined, such as *ideated sensation*, *spiritual significance* and *tactile value* (of these the last has even passed into specialist dictionaries of art terminology). Although many of Berenson's propositions are absurd, this is absurdity in the interests of genteel (and lucrative) mystification.

Berensonian artspeak nevertheless belongs to a period in which there is still not very much dispute about the greatness of great art: the canonical list of great artists of the past is well established. Hence the authenticity of attributions and the "quality" rating of the particular work assume paramount importance. The emphasis changes when we move into an era when all or most of the great works of days gone by have been discovered and bought up. What remain for the wealthy collector are the products of contemporary artists, often controversial and disturbing. Now the focus changes and artspeak has to be geared to persuading buyers that what is for sale "as art" really *is* art, even though it looks nothing like the (more expensive) art of the past.

The problem was a difficult one. We see Roger Fry, another art journalist who had risen to higher things, struggling to cope with it before the First World War. Occasionally it reduces him to making critical comments that take a lot of beating for sheer inanity. He once remarked of two abstract compositions by Kandinsky, exhibited in London in 1913, that "the forms and colours have no possible justification, except the rightness of their relations." According to Fry,

Kandinsky's forms and colours passed this alleged "test" of "rightness" and thus "established their right to be what they were." Here we have absurdity trying in vain to cloak the banality of the judgment. A "reason" has to be found for the critic's expert approval of Kandinsky's paintings. Only then have they a "right" to exist! But since the paintings are abstracts, this reason cannot be sought, as formerly, in the relation between the painting and what is depicted. So it *has* to reside solely and simply in relations between the forms and colours themselves. The logic of the comment shows a desperation verging on panic. It appeals vaguely to an unspecified doctrine of aesthetic harmony. But perhaps that is only to be expected from someone like Fry, chosen by the Muses to bring artistic enlightenment to a benighted capital. Such an elevated calling requires that one deliver even trivial observations in suitably Sibylline form.

In the end, critics began to fall back on tarting up stale formulas from the past. They are still doing it. The following example is chosen at random from *The Independent* (March 2008), whose art critic compliments a fashionable sculptor on having the bright idea of making plaster casts from his own body. Making a plaster cast of the human body! The originality is mind-boggling. (In sculpture the practice goes back to the ancient Greeks.) But no more mindboggling than the fulsome praise heaped upon it by the critic. These plaster-cast creations, we are told, "hum with a sense of the universal." But better still, they "test the limits of the self." Anything humming with a sense of the universal would surely have won the approval of both Berenson and Fry. As for testing the limits of the self, even philistines might perhaps be persuaded that a bit of

plaster casting on a Saturday morning in the garden shed is a less arduous way of doing it than running all those charity marathons.

Nevertheless, at this level we are still dealing with comprehensible absurdity. Different again is the absurdity of art writing that is so bad as to test the limits of comprehension. Here is one example among many:

> In the pre-"post-medium" days of modernism, such an acknowledgment would have carried the assumption that laying the conditions of the medium bare produces a kind of transparent self-evidence—the unassailable truth on which unity (material, ontological) and autonomy are based—and that such self-evidence as a function of the viewer's powers of analysis is reflexive, reempowering the viewer's own autonomy.

When academic authorities themselves write like this, they are presumably convinced that the best defence of art lies in obfuscation.

Nothing in this kind of absurdity could be further in spirit from the lucid, targeted absurdity of Dada. The contribution of Dada to the Great Debate cannot be overestimated. However, there is considerable disagreement as to what exactly that contribution was. Most critics, keen to stress the revolutionary character of the movement, fail to analyse exactly wherein the revolution lay. The exponents of Dada are sometimes seen not just as champions of anti-art but as champions of irrationalism in general. According to one philosopher, irrationalists "often seem to be inspired by a curious form of inverted rationalism: the rational response to an irrational world is to act irrationally." This can be made

to fit the Dadaists: their response to the hideous irrationality of the 1914-18 war was to subvert the artistic values on which European society prided itself, thus creating a ghastly mockery of those values and of the society that upheld them.

How difficult it is to subvert an established cultural category by deliberately setting up in the business of denying its validity is demonstrated by the relatively short time it took for the Dada movement to be recruited by art historians into art history, and for its artifacts to become collectors' pieces. The very society whose art values Dada rejected showed itself, Ades writes, "masochistically eager to embrace Dada and pay a few sous for its works in order to turn them into Art too." Institutionalists may well point to this as significant evidence in favour of the conclusion that what art "is" does not rest in the hands of artists. However vehemently artists may protest or revolt or campaign, it is not within their power to determine what shall count as a work of art. Furthermore, they are powerless to resist their own incorporation into the official annals of the very institution they reject.

However, none of this tells us what exactly the movement attempted to achieve and how. It was Hans Richter, one of the leading spirits of Dada, who came nearest the mark when, many years later, he described anti-art as the quest for "a new way of thinking, feeling and knowing." In short, Dada was something never before attempted in the Western tradition: it proposed a genuine epistemological experiment. To adapt Marx's famous dictum, the Dadaists saw that hitherto philosophy had merely interpreted human knowledge in various ways, whereas the paramount challenge was to change it.

# 8
# Art as Supercategory

Let's not look for analogies in the various forms in
which art is materialised.
                                    —Tristan Tzara

In retrospect it is clear that the 19th-century champi-
ons of art for art's sake had no inkling that the doctrine
which they were so proud to proclaim would set in
train a historical process leading not to the emancipa-
tion of artists—as they hoped—but to the collapse and
rejection of the traditional supercategory of art itself.
We are still living amid the debris resulting from that
collapse. In the wake of Dada, which brought the
internal contradictions of art for art's sake to crisis
point, it became clear what the Great Debate was all
about—and still is. It is about the status of art as a
supercategory. Institutionalism, idiocentrism and
conceptualism (or idealism) can all be seen as attempts

to preserve that supercategory status in the face of attacks upon it.

The epistemological function of supercategories is to provide an *a priori* classification of the forms of knowledge. The supercategories—such as, to confine ourselves to Western examples, Art, Science, Religion, History and Law—predetermine a society's approach to particular questions. If we think that something disputed is a matter of scientific fact, it will be approached quite differently from the way it would be if it were a matter of religious belief; if it is held to be a matter of artistic judgment, the arguments adopted will be quite different from those adopted if it were a question of historical accuracy; and so on. In this way, the supercategories that a society recognizes jointly provide the most general intellectual framework for the organization of different forms of knowledge in that society and, simultaneously, the classification of different questions about human activities that might be raised. The doctrine of art for art's sake was itself an emphatic assertion of the status of art as a supercategory.

Supercategories, however, have no permanent or sempiternal existence. They change over time, and the way they change has interesting epistemological implications. New forms of knowledge arise, while old forms of knowledge are neglected or recede in importance. From this point of view it is interesting to compare the fortunes of Science and Art in recent times.

Those who championed the doctrine of art for art's sake might well have supposed that they were backing a formula destined for success in the modern world. Insisting on intrinsic value in the pursuit of "$X$ for $X$'s sake" seemed to work very well in the case of Science. "Science for science's sake" never achieved the

public notoriety attracted by "art for art's sake," but it was the tacit credo that guided the 19th-century expansion of the sciences in the universities and research institutes of Europe and America. It also explains why, at the same period, we find a whole range of new disciplines (including psychology and linguistics) lining up to have their scientific credentials recognized. "Science for science's sake" was the exact counterpart of "art for art's sake": it asserted, in effect, that the first duty of the scientist was not to society, but to the unfettered search for scientific knowledge (in whatever branch of Science the scientist might be engaged in).

The difference was that, in the case of Science, society did not need convincing of the potential benefits that might ensue from funding scientists to pursue their own inquiries. By the time E.M. Forster wrote his belated plea in defence of art for art's sake, he was writing for readers who had learnt the lesson of the war with Germany: that cutting-edge Science was indispensable to the survival of nations in the modern world. Art had made no comparable contribution to the defeat of Hitler. Forster's unstated subtext is the fear that the sciences will henceforth command the lion's share of public funds, while the arts will be reduced to relying on charity (nowadays handed out in the form of proceeds from the National Lottery).

The sacred mantra of "science for science's sake" is still invoked when scientists fear that funding may dry up or be cut back; for example, in 2008 when awkward questions were asked about the usefulness of spending so much public money on projects such as particle accelerators. Doubts were even raised by the Government's former chief scientific adviser, speaking in his capacity as president of the British Association for

the Advancement of Science. But no sooner were these doubts raised than the scientific Establishment replied with one voice that unfettered inquiry, free from all considerations of public utility (and expense), was the essence of Science. The costly experiments with particle accelerators were held to "represent science at its finest," as Fong puts it. They *might* even throw light, we were told, on the answers to such unfathomable but momentous questions as the "Origin of the Universe." So far, there is little sign that they did. But the super-category rhetoric of "science for science's sake" carried the day with little or no opposition.

So why does not "art for art's sake" work simi-lar wonders in the public mind and on the public purse? The institutionalist answer is quite straightforward: the institutions supporting the arts are relatively weak and ineffectual compared with the powerful institutions supporting science. But this can hardly be the whole story. The sciences, however diversified, are united by scientists' reliance on "scientific method." There is no comparable "artistic method" that applies across the entire spectrum of the arts. Furthermore, in the arts the "X for X's sake" argument has been revealed as an epis-temological sham, whereas this is far less far less obvi-ous in the sciences, even though the sham is exactly the same in both cases.

"X for X's sake" is always an attempt to confer on some supercategory or other an epistemological hegemony beyond its *de facto* standing. In no sphere of human activity is there any intrinsic value in the pursuit of X for X's sake. Nor has there ever been. The notion that there might be does not even stand up to the scrutiny of common sense. This is because the human species is not given to enthusiasm for purposeless effort.

But in the sciences progress is always presented in question-and-answer format, in a way that makes no sense whatever where the arts are concerned. No one supposes that symphonies solve problems, or that portraits propose explanations. Whereas, in the sciences, disinterested inquiry is easily passed off as the ultimate goal of the scientist, to which the incidental benefits of public utility are entirely subordinate.

In fact, however, Science is not a cosmic quiz programme, in which questions are asked simply to see whether they can be answered. In every scientific field innumerable questions are never asked, and never will be, let alone answered. For there would be no point in wasting time on them. In spite of appearances, the pursuit of knowledge "for its own sake" is a quite misleading description of what motivates Science. The questions that interest scientists have to be interesting for a reason, and that reason, in each case, is to be sought in some antecedent programme of activity which has led up to asking it, and some purpose that answering it might fulfil. Questions do not suddenly drop out of a clear blue sky. Nor can they be decontextualized. To suppose otherwise is a recipe for talking epistemological drivel. There is no universal division of labour by which Nature poses the questions and Science answers them. It is human beings who raise the questions and human beings who answer or fail to answer them.

The idiocentric position clearly has epistemological implications. Where art is concerned, it affirms that only the individual can *know* what a work of art is. This knowledge, although assertable, cannot be shared with other individuals. It is a form of knowledge that is unique, derived from personal experience, and hence

of a different order from the knowledge with which Science is concerned.

Conceptualism likewise has epistemological implications. Hegel was at least aware of them, although it is doubtful whether as much can be said for the self-styled "conceptual artists" who proliferate on the modern art scene. Hegel was also aware of a tension between the claim that art is an end in itself and the notion that art expresses something that lies beyond art. This was also grasped by the more intellectually sophisticated members of the Dada movement, who rejected the idea that Dada was no more than a raucous, publicity-seeking manifestation of expressionism. The originality of Dada never lay in the search for new and outrageous forms of expressing a personal artistic vision. The point is important. It makes a crucial difference to understanding the epistemological role of the absurd and the meaning of "anti-art."

When the Futurists described their own movement as "anti-art," they were simply fulminating against the past. The Dadaists likewise rejected the artistic past, but theirs was a positive rejection in the sense that they wished to use the subversion of traditional artistic values and techniques as the basis for new ways of exploring reality, both intellectually and sensorily. This was the nub of their epistemological revolution.

Likewise, the cultivation of absurdity went far beyond the trivial satisfaction of shocking the bourgeoisie. The Dadaists saw the painting, literature and music of the past as attempts to impose a regulated, rationalized uniformity on the products of human creativity. Knowledge and access to knowledge, as conceived in the Western tradition, had to be restricted

in the interests of a well-ordered society. This rationalization, in the view of the Dadaists, must be rejected; not just for the iconoclastic hell of it, but because the controls and conventions built up over the centuries were seen as designed to repress those very aspects of human spontaneity that, although socially "dangerous," or potentially so, held the key to a fuller engagement with life. The difference was akin to pulling down a wall because it is ugly, or in order to annoy the builder, and pulling down a wall because it is blocking the view. (It is possible to pull down a wall for all three reasons combined, but the third is of a different order from the other two.)

# 9

# The Art of "I Spy"

The artistic regimentation and rationalization that the Dada movement rejected is perhaps best illustrated by the history of painting in the Western tradition. Here, under the hegemony of language, the painter's art is pressed into adopting a mimetic visual function as its primary objective.

This form of regimentation was already accepted in ancient Greece. According to Cicero, Zeuxis of Herakleia, when commissioned to paint a figure of Helen in the temple of Hera, requested that he be supplied with the most beautiful local virgins, "in order that the truth may be transferred to the mute image from the physical model."

If this anecdote is trustworthy, it leaves no doubt as to the artistic credo of one of the most famous

painters in antiquity. Zeuxis was also credited with painting a bunch of grapes with such exact fidelity to detail that birds were deceived into mistaking it for real fruit and pecked at it. Whether or not the story is authentic, it offers a prototypical example of admiration for mimetic verisimilitude in the visual arts. A similar respect for concern with mimetic detail is captured in Dioskorides' epigram on one of the works of the renowned sculptor Myron of Eleutherae:

> O bull, in vain do you nudge this heifer. For it is lifeless;
> Myron, the cow-sculptor, has deceived you.

When what is depicted is immediately recognizable, and intended to be, it seems unproblematic to accept that the depictions will be referred to by the same terms as those for the item depicted. Thus a statue of Zeus will also be called a *Zeus*, and *the grapes of Zeuxis* may refer either to the grapes themselves or to Zeuxis' painting. This lexical transfer is customary from the earliest times in Greek writing about art.

The tripartite correspondence thus set up between name (or description), object and depiction is the basis of what may be called "I spy" art. "I spy" art takes as its criterion for visual "representation" the production of a configuration enabling the viewer to supply straight away the word designating whatever is depicted. Thus, confronted with a drawing of a horse, the viewer responds with the word *horse*. Any drawing that does not elicit the word *horse* does not pass the test as a drawing of a horse.

The name "I spy" is taken from a game that children used to play to relieve boredom on wet holiday afternoons. (Nowadays they watch television.)

The original game of "I spy" was played like this. One of the group was selected to choose an object visible in the room. The only "clue" offered to the rest of the group concerning the identity of the chosen object was the first letter of what this object was called. Having chosen the object, the selected player then announced: "I spy with my little eye something beginning with...." Thus if the object was a book, it would be "beginning with B"; if it were a table, "beginning with T"; and so on. The game continued until someone guessed correctly, and then that person in turn took over the "I spy" role and fixed upon a different object. If no one guessed correctly, the others declared "We give up" and the winner proceeded to choose a second object. The aim of the game consisted in trying to hit upon an object that "no one would notice," even though it was plainly visible.

It was not at all obvious to those who amused themselves in this way what a sophisticated game this was. It had taken millennia of cultural evolution to equip the human child for playing it. What was needed was literacy, a fair command of English and a firm grasp of the alphabet. It was a game that presupposed a world in which everything had a name, and everyone knew what that name was and how to spell it. It could not possibly be played in a preliterate society, or one in which the established writing system was not alphabetic.

There was also a picture-book version of "I spy" that could be played by those who lacked playmates. In this, the reader was presented with pictures and challenged to spot how many objects visible in the picture began with—say—the letter B. (Answers in the back of the book.) This version is even more revelatory of the kind of culture from which it comes.

What exactly is it that a child playing picture-book "I spy" has to be able to do? First, the player must be able to recognize certain two-dimensional configurations of lines on paper as "pictures of" types of familiar object in the "real world"; that is, recognize one shape as a depicting a table, another as depicting a chair, and so on. Second, the player has to know what these things are called. Just recognizing the depicted object is not enough: the player must also know the name of that type of object in the linguistic community of which he or she is a member. But that is not enough either. What must also be known is how these names are spelled. It is of no use for little Johnny to recognize that there is a cat in the picture if he thinks that the word *cat* is written *kat*. In sum, the player must relate one type of linear configuration to another type of linear configuration through the intermediary of a quite different type of unit altogether, a "word." And it is this linguistic unit which provides the link. Thus linguistic knowledge, visual knowledge and knowledge of certain conventions of drawing combine.

What is involved, then, will be three types of correlation: correlating pictures with objects, correlating objects with words, and correlating words with spellings. If any of these links is missing, the integration of the activities required for playing picture-book "I spy" breaks down.

When we compare these three correlations, it may strike us that there is an asymmetry between them. Two of them involve language, whereas one apparently does not. The exception is the correlation of picture with object, the depiction with what is depicted. But if we consider the matter more carefully, it emerges that the exception is only apparent.

When we look at a typical "I spy" picture-book, it becomes evident that what has been drawn is designed to meet the requirements of the game. In other words, the artist has not drawn any particular scene from observation, but an imaginary scene constructed so as to include examples of certain types of object. For what the game requires is not the identification of any particular cat, or chair, or cushion, but the identification of examples of certain types or classes: *a* cat, *a* chair, *a* cushion. This is what is characteristic of "I spy" art. It is a form of depiction that involves *typification*.

That typification involves language. What counts is not whether one object looks like another to the artist's eye. What counts is whether two or more objects fall under the same verbal label. An artist deprived of language from birth would have no idea of the requirements for drawing an "I spy" picture, any more than a person born blind. The depiction, although ostensibly "non-verbal," is silently permeated with language.

Furthermore, the drawing will be language-dependent in another way. It makes a difference *which* language underlies it. An "I spy" picture for English children will not necessarily do for French children: it may have half a dozen objects "beginning with B" in English, but none at all in French. The artist needs to know in advance both what the language and the questions are in order to include a suitable number of depicted objects in each case.

Where does "I spy" art come from? Its forebears feature prominently throughout the Western tradition. It is a tradition in which it is of paramount importance not only to be able to understand *that*

something is being depicted but to be able to say *what* it is, regardless of whether you have ever seen the "real life" original. This is "a Roman soldier"; this is "a dragon"; this is "a sailing ship"; and so on *ad infinitum*. When we look at a typical 15th-century illustration from a book of hours, sometimes it seems that we can almost hear the artist planning his composition in advance, and saying to himself: "I will have a river in the foreground, and a grassy bank, and I will put a shepherd sitting on the left. Then I will have another shepherd on the right, and he will be holding a crook. And I will have a dog sitting between them, and some sheep grazing in a meadow behind. And to the right I will put a castle on a hill, with a road leading up to it. And across a river in the background will be a city gate and houses. And I will put an angel in the sky right in the centre, bearing his message to the shepherds on a placard."

We could without difficulty draw a plan of such a picture, substituting words for figures in the appropriate places: "river," "shepherd," "dog," "shepherd," "grass," "sheep," "sheep," "tree," "castle," and so on. Its whole method of pictorial composition is on one level simply a transference of words into corresponding visual units. That is why in "I spy" art of this kind the spectator can always reverse the process, and let the eye wander round the picture putting the appropriate verbal tag on every item. We can draw up an inventory of contents for such a picture. It reduces to a simple list of words.

This is not just unsophisticated medieval simple-mindedness. Among the masterpieces of "I spy" art are some of the great still-life paintings of the 17th century. Again, the eye of the beholder is almost invited

to draw up an inventory of the items on the table: "bread," "knife," "plate," "meat," "glass," "tankard," "table cloth." It is an art of itemization carried to extremes. We are left in no doubt that we are being shown a deliberate arrangement of separate objects, synthesized into a composition. To be sure, we are also expected to admire the painterly skill with which a Pieter Claesz renders this collection of objects, even if the objects themselves are not particularly interesting. But the point is that we could not even begin to admire that skill unless we could say *what it was* that the artist was depicting. *An unnameable object is not a candidate for inclusion in the classic still-life painting.*

That is no doubt one reason why the still life challenged and attracted the great Cubist masters. In their hands we can see "I spy" art deliberately turned upside down. There is a *Nature morte à la bougie* by Picasso which allows the viewer (just) to identify the candle, and then defies the eye to recognize any other single object on the table. Is this a glass lying on its side? It might be, but we cannot be sure. Or a key? We cannot say for certain. The whole composition is a witty fencing with the expectations of the "I spy" spectator who wants to be able to put a name to everything on display. "The cubist," Gombrich once remarked, "is not out to clarify a schema but to baffle our perception." But this is only half the truth. The cubist is also out to challenge our language. So too is the surrealist.

Once we recognize "I spy" art for what it is, we can have no doubt of the centrality of language in the mainstream vision which is characteristic of Western pictorial art. At the heart of that tradition is the unspoken premise that depiction is another form of naming,

just as in Western linguistics we find at the beginning the premise that names are labels of the objects named. Its importance can be measured by the fact that all the major innovations of the modern European art movements of the 19th and 20th centuries are in one way or another based upon challenges to or rejections of that premise. Modern painting and sculpture are often profoundly anti-linguistic. But so insistently anti-linguistic that, paradoxically, they only emphasize the centrality of language in those domains. By forcing us *not* to rely on words when interpreting what we see, they make us realize just how much we usually *do* rely on words for that purpose, and how much the artist does too.

Gombrich also tells us that "the innocent eye is a myth." The reference here is to that innocence invoked by Ruskin, who seems to have thought that a child sees a picture just as "flat stains of colour, merely as such." The innocent eye may well be a myth. But even were it not, the eye loses its supposed innocence the moment the child begins its apprenticeship to language. Before words came along the child did not even see flat stains of colour, let alone "merely as such." The things we see do not somehow *classify themselves* by their own visible criteria, independently of all else.

The "myth of the innocent eye" is not the only myth involved. There is also a much more ancient and powerful myth about language. It makes its first appearance in the Book of Genesis, where we are told how Adam first bestowed names on the creatures that God had made.

And out of the ground the Lord God formed every beast of the field, and every fowl of the air; and

brought them unto Adam to see what he would call them: and whatsoever Adam called every living creature, that was the name thereof. And Adam gave names to all cattle, and to the fowl of the air, and to every beast of the field [...].

Once Adam had performed this initial nomenclatorial task, and God had formed Eve out of Adam's rib, the only thing preventing Adam and Eve from playing "I spy" to amuse themselves in dull moments was the lack of an alphabet. It might even have kept them out of harm's way and distracted them from the wiles of the serpent. But writing, it seems, was not on the educational curriculum in the Garden of Eden. How does all this square with the traditional wisdom that tells us a picture is worth a thousand words? The fact is that what a picture is "worth" in this sense depends very much on what kind of information you are looking for and the context in which you are looking for it. One of Monet's paintings of Rouen cathedral tells you more about what the façade looks like (at least, as seen from a certain vantage point in a certain light) than any description Balzac might have given of it. But it does not tell you when the building was built, or where it is, or even that it *is* Rouen cathedral. For that kind of information words are needed, not better painting. And without information of the kind that words alone can supply, there is an obvious sense in which, when you look at Monet's painting, you do not know what you are looking at.

The facile "art-for-art's-sake" riposte says that what really matters is that you know you are looking at a painting, and the painting, as a work of art, is not "accountable" to anything other than itself. So all the

verbal information that can be supplied is at best an irrelevance and at worst a naive distraction.

That riposte, unfortunately, is based on a fallacy. Divorced from any verbal context whatsoever, there is no way you would even know it was a painting, any more than you would know what a five pound note was if you found one lying on the pavement. This fallacy lies at the heart of the Great Debate about art. What is fallacious about it is the assumption that artifacts can be classified just by inspection, which will reveal "naturally" just what they are and how they fit into the general scheme of things. That assumption is based on confusing the properties of the artifact with the properties of its material manifestation.

There is a parallel fallacy involved as well. It runs as follows. There is nothing triangular about the word *triangle*, either in its spoken or its written form. This apparently irrefutable observation seems to sum up, for many critics, the essential difference between linguistic communication and communication of the kind we are familiar with in the visual arts. In painting and drawing, the artist must seek to convey the idea of a triangle by presenting a visual form which itself has certain properties in which the viewers can directly recognize, or from which they can infer, triangularity. In verbal communication, by contrast, there is no such requirement. Moreover, no inspection or analysis of the word *triangle* itself could enable anyone to work out its connexion with actual triangles. It is just an arbitrary sign. This sign conveys "by convention" the idea of triangularity. How it manages to do so may be mysterious, but the mystery is accepted as an incontrovertible fact about the way language works. This basic dichotomy between word and visual image is then

adopted as the indispensable foundation for all further reflection on the subject.

Thus, according to traditional wisdom, "saying" and "showing" are two quite different forms of communication. The former is what underlies *inter alia* enterprises like literature, philosophy and jurisprudence. These are word-based activities. The other kind of communication underlies, *inter alia*, enterprises like painting, sculpture and photography. These are activities that can dispense with words. This is assumed to be a natural and necessary divide, because the visual arts are intrinsically pre-linguistic or non-linguistic.

Some 20th-century philosophers—notably Wittgenstein in *Tractatus Logico-Philosophicus*—made a great song-and-dance about the difference between saying and showing. This distinction itself cannot get off the ground without invoking, as Wittgenstein does, the notion of a picture (*Bild*):

> We make to ourselves pictures of facts (*Bilder der Tatsachen*).
>
> The picture presents the facts in logical space, the existence and non-existence of atomic facts.
>
> The picture is a model of reality.
>
> To the objects correspond in the picture the elements of the picture.
>
> The elements of the picture stand, in the picture, for the objects.
>
> The picture consists in the fact that its elements are combined with one another in a definite way.
>
> The picture is a fact.
>
> That the elements of the picture are combined with one another in a definite way, represents that the things are so combined with one another.

Wittgenstein goes on to argue that:

In order to be a picture a fact must have something in common with what it pictures.

In the picture and the pictured there must be something identical in order that the one can be a picture of the other at all.

Wittgenstein proceeded to develop the idea that a proposition must have a logical form which it shares with what it states. Whatever one may think of this approach (which Wittgenstein later rejected) to what is often called the problem of "representation," its basis is clear enough: the assumption that pictures are pictures *of* something, and that they depict in virtue of have something in common with what is depicted. (The crucial question then becomes identifying what this commonality consists in.) Furthermore, this approach takes for granted the primacy of the pictorial over the verbal, a primacy also granted by a long line of philosophers, going back to Plato. In short, the verbal (propositional) is to be understood by reference to the pictorial, not vice versa.

Against the consensus of traditional wisdom, it can be argued that this kind of priority is itself a cultural product, which actually misrepresents our experience of communication. The misrepresentation is central to the conduct of the Great Debate. The truth is that our visual and verbal worlds are integrated worlds. They can indeed be *separated*; but they are separated in first-order experience only when an individual has the misfortune to be deprived of language or deprived of sight.

In brief, the category "picture" is itself a linguistic construct and depends in part on having a vocabu-

lary in which to articulate it. And the same is true, as the Dadaists were the first to realize, of every other category of artifact that is recognized in the traditional world of the visual arts. Saying and showing are integrated activities right from the start. Knowing that this is a portrait of Napoleon depends on knowing that the person here shown was called *Napoleon*. Knowing that this is a picture of book depends on knowing that such things as are here depicted are called "books." Were it otherwise, no six-year-old could cope with playing any game as complex as picture-book "I spy" on a wet Wednesday afternoon in the summer holidays.

Even those who see this, however, often fail to see that what is true of the category "picture" is also true, *mutatis mutandis*, of the supercategory Art, which subsumes that of "picture." The difference, simply, is that Art cannot be depicted.

# 10
# Art as ambiguity

> The very narrow conception of imitation which art
> has been given as its aim is at the bottom of the seri-
> ous misunderstanding that we can see continuing
> right up to the present.
>
> —André Breton

The epistemological legacy of Dada was assimilated
very unevenly by Dada's immediate successors, the
surrealists. Under the humourless leadership of Breton,
many were diverted into Freudian labyrinths. Perhaps
the only surrealist who really understood what Dada
had hoped to accomplish was René Magritte.

The author of the catalogue to the Arts
Council's exhibition of René Magritte's work (Sylvester)
in London in 1969 wrote: "Magritte's paintings speak
for themselves more perhaps than any other paintings of
our time." If that were true, then all one can say is: so

much the worse for the other paintings. What Magritte's paintings "say"—as distinct from what they "show"—is in many instances far from clear. A number of them seem indeed to be pointing to the difficulties involved in saying anything clearly at all.

Among them is Magritte's famous picture of the pipe with the words "Ceci n'est pas une pipe." This is often regarded as an example of deliberate verbal and visual ambiguity, where the artist has set out to puzzle us as to which of various possible interpretations we should opt for. If that was indeed his intention he succeeded admirably, to judge by the efforts that have been made by art critics and others to resolve the problem in question. We find Magritte described as an artist who "multiplies" ambiguities (although it is not quite clear what the artistic point would be in multiplication of ambiguities, whether by Magritte or by anyone else, unless one's goal were wilful bewilderment).

Magritte did, however, go on to produce a number of variations on the theme of the original work, which can perhaps be regarded as commentaries on or extensions of it. These include drawings to illustrate Michel Foucault's essay on the painting; an English version of 1935, where the text reads "This is not a pipe" (but the pipe itself is a different pipe); and *Ceci n'est pas une pomme* (1964), where that sentence accompanies a very meticulous painting of an apple. So we are evidently dealing with a verbo-visual formula, of which there could be innumerable realizations. The basis of the formula is the juxtaposition of an "unmistakable" picture of a certain type of object and a sentence which seems to deny that the picture in question represents what it manifestly appears to represent. Perhaps conceptualists will argue that the "work of art"

that Magritte has produced here is the formula itself, i.e. the concept of confronting a certain type of pictorial representation with its verbal contradiction.

All this makes much more sense when we realize that, following the trail blazed by Dada, Magritte's target is the whole epistemological tradition of "I spy" art: he wishes to question the traditional assumption that there is a perspicuous, unproblematic relationship between what a Zeuxis can paint and the object supposedly depicted. "Ceci n'est pas une pipe" forces the viewer to confront the question: "What do I *know* that requires me to interpret this as a picture of a pipe?"

That knowledge, Magritte implies, reduces to nothing more solid or reassuring than familiarity with two sets of conventions, one verbal and one pictorial. But if we are genuinely in search of "a new way of thinking, feeling and knowing," in accordance with the goals of anti-art, the first thing we must learn is to question the rationale of "I spy" representation, which is based on the authority of language. The "I spy" artist, from Zeuxis down to Rembrandt, adopts conventions and techniques designed to allow the spectator to put verbal labels on what the picture "shows." This is the tyranny from which visual art still has to be liberated. That path of liberation is signposted in many of Magritte's other paintings. They include *La Clef des Songes* (1930), which consists of six panels each showing a picture of an object with a word underneath. But in no case do word and picture "match" according to the "I spy" convention. What is clearly an egg is labelled *acacia*, a high-heeled shoe is labelled *the moon*, a bowler hat is labelled *snow*, and so on. A variant on the same theme is to be found in *Personnage marchant vers l'horizon* (1928-9), where the

horizon is represented as a vaguely triangular blob bearing the word *horizon*, while other blobs in the same picture bear the words *fusil*, *fauteuil* and *cheval*. These inscription-bearing blobs are thick, voluminous masses which cast "shadows" in the picture; but in no case do the shapes bear any resemblance to those of a gun, an armchair or a horse.

The irony is that, technically speaking, Magritte himself was an accomplished "I spy" draughtsman and painter—far more so than any of the Dada group. His deliberate use of meticulous "I spy" representation in order to call its foundations in question is all the more telling. "I spy" art, in effect, applies to pictorial representation the same semiology as traditional grammar applies to words. In that tradition, going back at least as far as Plato and Aristotle, words are held to "stand for" things. Thus if we fail to recognize Zeuxis' picture as a painting of grapes, we have not understood what it "means." The painted configuration "stands for" the grapes depicted. Just as the word grapes "stands for" the fruit thus designated. So asking what a picture represents is assimilated to asking for the meaning of a word or a sentence. Recognizing what is depicted is analogous to being able to supply the right word or words to describe it. In fact, being able to do just that ("This a painting of grapes") is fundamental to the semiology of "I spy" art, and provides *prima facie* evidence that the spectator has indeed understood the "meaning" of the picture.

With Magritte, this epistemological house of cards comes tumbling down. Anti-art triumphs by borrowing the very techniques that were designed for art. If there are "ambiguities" here, they are ambiguities of a different order from those recognized by most art

critics and historians. For the latter-day champions of "I spy" theory, ambiguity is a crucial notion.

Ambiguity, according to Ernst Gombrich, holds the key to all forms of pictorial illusion. Gombrich speaks of "the inherent ambiguity of all images," i.e. not just those of *trompe l'oeil* artists who set out to deceive. In looking at any and every picture, according to Gombrich, we have to make an imaginative effort to resolve the ambiguities which it necessarily presents to the eye. Gombrich says we have to "decode those cryptograms on the canvas" and in this we are hampered by our "reluctance to recognize ambiguity behind the veil of illusion."

In these and many other passages Gombrich is using the term *ambiguity* quite differently from the way it is generally used in linguistics. Linguists usually distinguish between "lexical" and "syntactic" ambiguity. Lexical ambiguity is held to be due to the fact that a particular word has more than one meaning. Thus *the file is missing* is ambiguous simply because *file* could designate either a document folder or a type of hand tool. On the other hand, *young trees and shrubs* is syntactically ambiguous; not because any individual word is ambiguous, but because in that combination the adjective *young* could be taken as qualifying just *trees* or as qualifying both *trees* and *shrubs*. Similarly, in *losing players can cause problems* it may be the players who can cause problems or losing them that can cause problems.

Arguably, there is nothing in pictorial ambiguity that corresponds exactly to the lexical vs. syntactic distinction recognized by linguists. If we cannot tell whether the man half-way up the ladder is supposed to be going up or coming down, that is not because of any ambiguity in the pictorial elements themselves, or in

the way they are combined. If we cannot tell whether the animal in the foreground of the picture is a horse or a donkey, this is either because the painter has not painted it well enough or because the angle from which it is shown does not allow the distinguishing features to be seen. Examples of what Gombrich calls "incomplete representation" in painting are not the counterpart of lexical ambiguities, but of uncertainty in what linguists would call "phonological form" ("Did he say *cat* or *cad*?"). Similarly, a standard case of pictorial ambiguity, the "duck/rabbit" which can be seen either as a duck or as a rabbit (but not both at once) is not the visual analogue of a syntactic ambiguity in grammar, as it is often assumed to be. The "duck/rabbit" shows something rather different; namely, uncertainty about the interpretation of the whole, rather than uncertainty about how its individual parts relate to one another. When we see the drawing "as a duck" there is no rabbit at all, nor any part of a rabbit. Likewise, when we see it "as a rabbit," there is no duck. By contrast, in *losing players can cause problems* reading the first word as a gerund does not make the rest of the sentence disappear, any more than the alternative of reading it as an adjective. Whichever way we take the ambiguous sentence, the individual components *lose*, *player* and *cause problems* remain recognizably the same.

From Gombrich's point of view, European perspective drawing as developed in the Renaissance provides a whole system of disambiguations that earlier drawing lacks. The size of objects depicted diminishes systematically as they recede into the pictorial distance, thus allowing the viewer who understands the system to locate their relative positions. Perspective drawing is in this sense a pictorial "language" with its own explicit

rules (i.e. we can detect and describe infringements and inconsistences in the execution of particular works).

Gombrich's insistence on ambiguity and illusion as keys to analysing visual art has epistemological implications that he never makes explicit or confronts. The artist emerges as one who is skilled in constructing and exploiting certain types of illusion, a master of making the viewer "see" what is not "really there." This in turn presupposes that the picture is to be judged as nothing more than a visual surrogate for the "reality" depicted. Magritte had already satirized the naivety of this theoretical approach as early as the 1930s in *Ceci est un morceau de fromage*, where the viewer is presented with a framed painting of a piece of cheese, mounted on a real dish, complete with glass cover.

# 11
# Art Inside Out

> Our interest is not in movements, but in something much rarer, authentic individuals.
>
> —Michel Tapié

A supercategory can afford to breed heresies. But how many self-contradictions can it afford? How long would the credibility of "Science" last if scientists started to renounce any reliance on "scientific method"? Odd as it may seem, a roughly parallel situation has arisen in the Great Debate about Art.

The resilience of the modern artworld Establishment was demonstrated by the relative ease with which it absorbed the Dada crisis and thus, in effect, denied Dada the status of "anti-art." The success of this *fait accompli* (engineered mainly by collaboration between art dealers and art historians) retrospectively masks the scale of the achievement. By comparison

with other supercategories, it is roughly on a par with, say, declaring atheism to be a religious doctrine acceptable to the orthodox church.

However, once the *volte-face* of accepting Dada had been accomplished, the way lay open to an endless proliferation of artistic self-contradictions. One of the more interesting (because it highlights the role of verbal labels in what counts as "art" today) is the distinction that became popular in the 1970s between "insider art" and "outsider art."

In effect, this divided the supercategory of art into two new mutually exclusive subcategories. The expression *outsider art* originated as a (mis)translation of the French *art brut*. It was introduced in 1972 by Roger Cardinal in a book bearing that title, although Cardinal himself still preferred to call it *art brut*. This in turn was the coinage of the French artist Jean Dubuffet, who developed a consuming interest in the paintings and drawings done by psychiatric patients, and amassed a large collection of such work.

There is no doubt about Dubuffet's hostility to the Establishment artworld of his day, the promoters of what he called "cultural art." He wrote:

> What country doesn't have its little section of cultural art, its brigade of professional intellectuals? They're indispensable. From one capital to the next, they all parrot one another marvelously, practicing an artificial art, an Esperanto art, indefatigably recopied everywhere. Can we really call it an art? Does such activity have anything at all to do with art?

What Dubuffet originally meant by *art brut* when he introduced the term is explained as follows:

What we mean is anything produced by people unsmirched by artistic culture, works in which mimicry, contrary to what occurs with intellectuals, has little or no part. So that the makers (in regard to subjects, choice of materials, means of transposition, rhythms, kinds of handwriting, etc.) draw entirely on their own resources rather than on the stereotypes of classical or fashionable art. We thereby witness the pure artistic operation, unrefined, thoroughly reinvented, in all its aspects, by the maker, who acts entirely on his own impulses.

Such art was to be sought, in the first instance, in the productions of individuals excluded from mainstream society. These Dubuffet saw as being primarily those confined in mental hospitals and prisons. His interest in these groups was influenced by a book published in 1922 by Hans Prinzhorn on the art of the insane (*Bildnerei der Geisteskranken*). A more dubious inclusion was the art produced by small children, presumably on the basis that the very young have not yet had time for their artistic impulses to be tamed by society. (In taking an interest in children's art, however, he had been anticipated by Klee and Kandinsky.)

From its inception, the concept of *art brut* invited controversy, as did the role of Dubuffet himself. Sceptics accused him of inventing an aesthetic theory and using it to promote his own interests and enhance the importance of his own (rather limited) range of artistic productions. Colin Rhodes observes:

> By way of his continued collecting activity and a sustained polemic in favour of art created outside the mainstream, Dubuffet assumed the position of arbiter of Art Brut and the relative quality of its

inclusions. In this way a position that had originally been born of a desire to escape the straightjacket of the art market now threatened, ironically, to develop into an "alternative" orthodoxy.

Whatever judgment may be made about Dubuffet's motives, there is no doubt that he deserves his place in the story of the Great Debate, since his work raises once again the question "What is a work of art?," and in a way that went beyond the iconoclasm of Dada. Dubuffet was not interested in anti-art, but, on the contrary, in "authentic" art and the "authentic" outsiders who produced it.

Historians of art are quick to point out that interest in art "outside" the Western mainstream goes back much further than Dubuffet. The fascination that "primitive" art exercised on Picasso and other Western avant-garde artists long antedated the coinage of the term *art brut*. One might at first think that works originating in far-flung parts of the world were equally well qualified to count as "outsider art." But Dubuffet's case for *art brut* was based on a more circumscribed and divisive theory. It appealed to a philosophical distinction between the natural and the artificial. Basically, its contention was that all cultural traditions sponsored by society distort or pervert art. African masks were not more "primitive" works of art, but simply the products of a different cultural tradition. Art, for those who think like Dubuffet, is an innate impulse for creating images which is common to the whole human race.

As regards children's art, it is relevant to point out that psychologists were publishing books and articles on the subject in the 1880s. Herbert Read quotes

the following passage from Ruskin's *Elements of Drawing* (1857):

> I do not think it advisable to engage a child (under the age of twelve or fourteen) in any but the most voluntary practice of art. If it has talent for drawing, it will be continually scrawling on what paper it can get; and should be allowed to scrawl at its own free will,...

Thus far Dubuffet, if he had ever read Ruskin, would presumably have agreed. But that agreement would have stopped short when Ruskin continues:

> due praise being given for every appearance of care, of truth, in its efforts. It should be allowed to amuse itself with cheap colours almost as soon as it has sense enough to wish for them. If it merely daubs the paper with senseless stains, the colour may be taken away till it knows better; but as soon as it begins painting red coats on soldiers, striped flags to ships, etc., it should have colours at command and, without restraining its choice of subject in that imaginative and historical art, of a military tendency, which children delight in (generally quite as valuable, by the way as any historical art delighted in by their elders), it should be gently led by the parents to draw, in such childish fashion as may be, the things it can see and likes—birds or butterflies, or flowers or fruit.

At this point the apologist for *art brut* would be throwing up his hands in despair. For what Ruskin describes—and recommends—is precisely the process by which the child's "natural" artistic urge is corrupted by culture. For Ruskin, art is a supercategory still in thrall to the mystique of "I spy" representation.

The trouble with Dubuffet's naive conception of a distinction between *art brut* and "cultivated" art is that its basic premise does not stand up to serious scrutiny. There is no evidence that all humanity shares a common, spontaneous urge for artistic expression. There is no evidence that the paintings and drawings of psychotics are closer to the hidden psychological springs of human art than the work of trained artists. On the contrary, research suggests that what psychotics draw or paint is often influenced by the works of "orthodox" painting and sculpture they have seen.

Once the buzzword *art brut* is translated as "outsider art," the theoretical problems multiply. The distinction is now transferred from the art itself to the social status of the individuals who produce it. But there are at least some social "outsiders" (e.g. among those confined in mental hospitals, prisons, etc.) who can and do produce "images" indistinguishable from those of "insider" artists. The problem is complicated by the fact that "outsider" artists can be taken up and promoted by "insiders." (Their art is exhibited in galleries, bought by collectors, etc.) They then lose their status as "outsiders." It is sometimes claimed that once artists make the transition from the outside to the inside their art deteriorates in quality. But again there is little objective evidence to support this.

The consensus nowadays seems to be that work produced by so-called "naive" painters who have received no artistic training does not *eo ipso* count as genuine outsider art. Thus the amateur paintings of "le Douanier" Rousseau, over which Picasso enthused, have eventually found their way into the National Gallery, the Metropolitan Museum and the Musée d'Orsay. Nothing could more emphatically demonstrate

their eventual acceptance into the realm of insider art. Rousseau even exhibited at the Salon des Indépendants as early as 1886. But this does not tell us what the status of Rousseau's paintings *as art* would be if he had never exhibited at all and died in obscurity, without being fêted by influential figures more celebrated than he. In other words, there remains a suspicion that we are dealing here with a confusion of criteria: what seemed originally to be a question about the source of inspiration and technique has been overtaken by considerations about the eventual public reception of the work. All this is grist to the institutionalist mill.

What theorists of outsider art are not keen to discuss is whether it matters how the outsider in question regards the work. Does it matter whether the outsider's motives have nothing to do with art at all? For the "complete" outsider—i.e. one entirely unacquainted with any established artistic tradition or practice—what would it mean to say that such-and-such is a "work of art"? What kind of judgment would this be? Or is the whole category of outsider art an insider's category from start to finish?

In the end the distinction "inside" versus "outside," far from explaining anything about particular works of art, simply directs the Great Debate into a dead end. One of the prime culprits here was Dubuffet himself. He was guilty on at least two counts. During his lifetime he promoted exhibitions of *art brut* and eventually bequeathed his collection of psychotic art to be exhibited to the public. This itself betrays a desire to see "authentic" *art brut* accepted into the familiar world of the art Establishment.

Worse than that: although an "insider," Dubuffet deliberately painted in the manner he

conceived to be characteristic of "outsiders." He would use, for example, an impasto concocted of mud and broken glass, into which shapes were scraped or slashed. His pictures show a scrupulous avoidance of any features that might be identified as the result of exposure to cultural expectations about what a picture should "look like." As a result—inevitable in the perverse modern artworld—the term *art brut* has come to be applied to Dubuffet's own work. Dubuffet's style, however, is far from being the product of untutored spontaneity. On the contrary, it shows a carefully monitored, sophisticated straining for certain pictorial effects.

It was the advent of *art brut* that convinced the general public that the gurus of the fashionable artworld had finally lost the plot. Many found it impossible to see any artistic merit in seemingly random daubs and scribbles, lauded *because of* their failure to conform to recognizable standards of technical competence. Dubuffet may have managed to turn art inside out. But the paradoxical price of that achievement was to make it impossible henceforth to distinguish visually between the inside and the outside.

## 12

# In Defence of the Turner Prize

All art was modern once.

—Nicholas Serota

Nothing reveals more clearly the current state of the Great Debate than the boringly predictable, carefully orchestrated fuss about the annual winner of the Turner Prize. The champions and foes of idiocentrism, institutionalism and conceptualism all play their well-rehearsed roles. The public now yawns, having seen it all before.

The prize itself ostensibly commemorates the name of the great British painter J.M.W. Turner, although, as has often been pointed out, any present-day painter who could paint as well as Turner would stand no chance even of reaching the Turner Prize shortlist. The Prize competition was inaugurated in 1984 and since 1988 has been masterminded by the

controversial director of the Tate Gallery, Sir Nicholas Serota (who in his student days had written an MA thesis on Turner). Serota's knighthood was awarded in 1999. He acted as chairman of the Turner jury from 1988 until 2007 and was its only permanent member. The partisan preferences of the jury, which often seem remarkably to coincide with Serota's known views on art, have prompted opponents, often in a spirit of mockery, to set up rival prizes (including the "Real Turner Prize," the "Anti-Turner Prize" and the "Not the Turner Prize") by way of protest. In so doing they have, perhaps unintentionally, contributed to what has degenerated into little more than a media circus, as even the media commentators admit. The prize money, currently £40,000, is given by commercial sponsors, which have included Channel 4 television. The whole event has been described as an "annual farce" (Brian Sewell, *Evening Standard*) and, even more dismissively, as "conceptual bullshit" (2002, Kim Howells, then junior minister at the Department for Culture, Media and Sport).

Publicity and self-promoted controversy have played a crucial role in the success, or at least the notoriety, of the Turner Prize. In 2001 the celebrity chosen to present the prize was the pop star Madonna, who, in the course of the (broadcast) ceremony used the word *motherfuckers*, thus ensuring a rumpus which duly culminated in Channel 4 receiving an official rebuke from the Independent Television Commission. In 2006 Serota had himself photographed holding up an anti-Serota leaflet which depicted him inspecting a pair of knickers hanging on a clothesline and wondering whether the garment was "a genuine Emin." In the same year, even one of the jurors broke silence, publicly

questioning the process by which the shortlist had been chosen and asking whether it was not "all a fix."

It will be obvious from the above summary of its history that where the Turner Prize is concerned it is not a straightforward matter to distinguish showbiz considerations from arguments about art. But some such attempt is necessary if one is to learn the lessons that are there to be learnt about the current state of the Great Debate. By the same token, it is essential to set aside, as far as possible, not only the personalities involved but the quasi-political/economic factors about private and state sponsorship of the arts. These are red herrings. Interestingly, both apologists for the Turner Prize and its opponents seem to feel obliged to publish arguments in defence of their positions on art. Even if they agree with Berger's doctrine that "seeing comes before words," they nevertheless fall back immediately on words when it comes to justifying the way they see things.

Berger himself, it must be admitted, had not overlooked the paradox inherent in having to elaborate verbal arguments in order to establish the primacy of the visual in art. Because he recognized that paradox, his book *Ways of Seeing* includes what he calls three "purely pictorial essays." These consist simply of sequences of images, some of well-known paintings. They are, says Berger, "intended to raise as many questions as the verbal essays." But the demonstration is self-defeating. What the "pictorial essay" fails to do is—precisely—to raise any questions at all. It is the viewers who are left to supply their own questions as part of a guessing game about what the "message" of the essay is supposed to be. Even less do these essays propose any answers to the questions they purportedly raise. Seeing may well come before words; but it does not come before arguments.

Both sides in the Turner Prize controversy evidently see where Berger had gone wrong. To that extent, perhaps, it might be said that the Great Debate has now moved on from where it was in the 1960s. No one thinks that the simple solution is to invite people to "see for themselves." In part this may be an acknowledgment of the fact that nowadays there is often very little on view to be seen. (The winner in 2001 submitted a display consisting of an empty room in which the lights went on and off at intervals.) That makes it all the more interesting to examine the arguments chosen.

The clearest exposition of the philosophy behind the Turner Prize is that presented by its chief architect, Serota, in his Richard Dimbleby Memorial Lecture of 2000, entitled "Who's afraid of modern art?" Serota began by acknowledging that modern art is a "problem." He even cited the decision by a Civil Service inquiry in 1987 that the salary of the Director of the Tate Gallery should match those earned by the directors of the Victoria and Albert Museum and the National Gallery because "the Director of the Tate has to deal with the very difficult problem of modern art."

By way of illustrating this "very difficult problem," Serota quoted three of the newspaper headlines which greeted the announcement of the winner of the previous year's Turner Prize. They were: "Eminence without merit" (*Sunday Telegraph*), "Tate trendies blow a raspberry" (*Eastern Daily Press*) and "For 1000 years art has been one of our great civilising forces. Today pickled sheep and soiled beds threaten to make barbarians of us all" (*Daily Mail*). (The reference to "pickled sheep" is to Damien Hirst's work *Away from the Flock* [1994], a dead sheep floating in a tank of fomaldehyde, while "soiled beds" refers to Tracey Emin's Turner Prize

exhibit *My Bed*, which consisted of an unmade bed, complete with dirty sheets, vodka bottles, soiled knickers and used condoms.)

To judge by this curious *entrée en matière*, Serota's "problem" seems to be nothing more than a hostile reaction from the press. But Serota reads that hostility as symptomatic of the public's "deeply suspicious" attitude to modern art.

> Why should this be so? Why is modern art apparently so intractable? Are the artists simply emperors parading in their new clothes? What lies at the root of a fear that we are being deceived or tricked? Is this art which can have meaning for the many or is it simply for the few, those critics, curators and collectors who form an inner circle?

So straight away the misgivings of the public are implicitly attributed to one or other of just three possible causes: a failure to understand "difficult" art, distrusting the *bona fides* of the current generation of artists, and a rejection of elitism. Possibly all three. At the same time, the defence of modern art is tacitly assumed to rest on being able to allay these three kinds of suspicion.

The first thing that strikes one about this strategy of argument is its double disingenuity. It never crosses Serota's mind to concede that press criticism of the 1999 Turner Prize entries might have been on target, and perhaps the jury had made a poor choice. That possibility is simply not allowed to cross the horizon. In the second place, there is no hint that a hostile press reaction might be something that the sponsors of the Turner Prize would be quite happy to see, or even that the success of the event is in any way dependent on

provoking such a reaction. In short, the analysis of the "problem" already treats the public as unsophisticated simpletons.

So too does Serota's solution. He begins by explaining how, as a schoolboy, his life was changed by a single visit to the Tate Gallery, where he saw an exhibition which ranged from the mature works of Picasso and Matisse down to those of the young Allen Jones and David Hockney, then in their late twenties. The impact of this single exhibition was stunning:

> Suddenly, art was not just Turner and Constable, or Leonardo and Michelangelo, but objects of considerable size and brilliant colour, dealing with the sensations, subjects and issues of the sixties.

Such an experience, Serota implies, lies potentially in wait for the young person paying a first visit to the Turner Prize exhibition, or any comparable show. It has the capacity to expand immediately one's previously limited understanding of what art is. In the case of the young Serota, evidently, that understanding had been based on a prior acquaintance with the art of earlier centuries. The difficulty that Serota proceeds to identify is this: it is indeed the art of the past that forms people's expectations about art. It offers, for example,

> the experience of space, light and colour in Chartres Cathedral, the muscular beauty of a young male torso in a Michelangelo drawing, the poise of Vermeer's girl reading a letter, the radiance of nature in a Constable oil sketch. But for many people it remains hard to see how similar qualities can be found in the art of our own time.

Again, the disingenuity of the argument is remarkable. The fact is that "in our own time" many artists—perhaps the majority—are still producing art with "similar qualities." For Serota, however, this does not count as "the art of our own time." What is "of our own time" is implicitly restricted to the kind of art being produced by the carefully selected candidates for the Turner Prize.

It is at this juncture that the familiar doctrine that "seeing comes before words" makes its first appearance in Serota's argument. Although there is no overt reference to Berger, the provenance is unmistakable:

> I'm sure it's no coincidence that my curiosity, interest and enthusiasm for the visual were first stimulated not by parental example, not by text, lectures or history, but by encounters with works of art themselves. In my view, there can be no substitute for a direct confrontation with the painting, sculpture, photograph, installation or film, the visceral experience of allowing it to register on the eye, body and imagination.

From this belief stems Serota's professed curatorial creed. The function of museums is to "provide a space for this kind of experience."

Here all the strands in Serota's underlying psychology of art begin to come together. The key to everything is that eureka moment when one's eyes are opened. We are not dealing here with persuasion but with *revelation*. Those who are blind will never see. Nor will purely verbal arguments ever overcome their blindness.

The religious resonances of all this are unmistakable. They are reinforced when Serota proceeds to

"explain" the meaning of a work by Michael Craig-Martin entitled *An Oak Tree*. It consists simply, as Serota describes it, of "a glass of tap water placed on a glass bathroom shelf." How can this collection of mundane utilitarian objects constitute a work of art? Serota's account runs as follows.

> In an interrogation placed alongside the work the artist asserted "It's not a symbol. I have changed the physical substance of the glass of water into that of an oak tree... I didn't change its appearance... The actual oak tree is physically present, but in the form of a glass of water." We may not "like" Craig-Martin's work, but it certainly reminds us that the appreciation of all art, including painting, involves an act of faith comparable to the belief that, through transubstantiation, the bread and wine of holy communion becomes the body and blood of Christ.

Thus, just as having one's eyes suddenly opened to art is assimilated to religious conversion, so the contemplation of the work of art is construed as participation in a religious sacrament.

Whether or not we are convinced by Serota's theory of art-as-quasi-religious-experience, the first interesting point to note is that it *is* a theory, i.e. resolves itself into a series of propositions; and that resolution is necessary if it is to play any role in the Great Debate at all. Even more interesting, however, is that the very process in which this theory is brought together as a statable series of propositions, illustrated by current examples, is also the process in which it begins to unravel. The central difficulty that Serota dodges is obvious: how does the public know, when

reverently contemplating Michael Craig-Martin's glass of water, that an "actual oak tree is physically present"? The answer is that they have to read the accompanying notice that the artist has provided. Without words, no amount of staring at the object will do the trick. The transformation from bathroom accessory to work of art is totally language-dependent.

Furthermore, the act of faith that Serota in practice is calling for is faith in the high priest, i.e. the museum director. He is the person responsible for ensuring that the church (= museum) remains a consecrated space where the revealing experience of art is possible. Here, in short, Serota's theory of art surrenders unconditionally to the logic of institutionalism.

Although institutionalist through and through (as one might expect from the highly paid head of a public institution), Serota's theory reveals two important compromises with idiocentrism. One of these becomes apparent as soon as we ask how it is that Serota himself knows that the oak tree is physically present in the glass of tap water. The answer is that the artist says so. Otherwise Serota, like the rest of us, might have stared for a fortnight at the visible glass of water and been none the wiser. So ultimately the artist is the sole arbiter of what his work means.

The other compromise, perhaps even more surprising when coming from the director of a major public gallery, emerges in Serota's confession of how difficult he often finds it to revise his own ideas about art when confronted with the unexpected.

> I am very familiar with the experience of being completely at a loss when confronting a new idea or image. [...] A visit to a studio never fails to test my

resources. It constantly reminds me of the condition in which most people first confront contemporary art. This is a state of "not knowing," of "not understanding," of being disorientated or challenged by the unfamiliar. [...] But I've come to realise that it's precisely when I am most challenged in my own reactions that the deepest insights emerge.

As the above passage illustrates, "challenge" is one of the notions Serota most frequently appeals to in his defence of modern art. Facing up to challenges is evidently a "good thing." He seems not to notice how this assumption inevitably draws him into the idiocentric camp. For presumably not all the challenges he encounters in the studios are worth taking up. Furthermore, "challenge" is itself an entirely idiocentric notion. What one person finds challenging, another will dismiss or even fail to see.

Finally, the whole *An Oak Tree* example shows the conceptualist approach to art in its most radical form. We never actually *see* the oak tree; its material identification with the glass of water is purely an operation of the mind.

What makes Serota's theory of art original—and as "of our time" as his favourite artists—is the muddled way it manages to combine institutionalism, idiocentrism and conceptualism—the three major artistic dogmas of the twentieth century.

# 13

# A Science of Art?

*Painting is a science, and should be pursued as an inquiry into the laws of nature.*

—John Constable

One way of solving mysteries and settling debates is to show that there is a "scientific" solution. Is there any reason why, in principle, it should not be possible to come up with a scientific answer to the question "What is a work of art?" In other words, could the former supercategory of Art become absorbed into the supercategory of Science? The very notion would have been enough to give E.M. Forster apoplexy.

It is uncontentious to say that science is already relevant to works of art in many different ways, such as the detection of forgeries, the restoration of paintings, etc. It is equally uncontentious that advances in science may provide the basis of new art forms and

their development. The invention of photography (notwithstanding the initial reluctance to accept photography into the ranks of the visual arts) would be an obvious example. In these cases the artist and the art student clearly make use of expertise provided by the scientist. But connexions of this order between the work of the scientist and the work of the artist do not involve the *de facto* establishment of a science of art.

Perhaps the earliest move towards a genuine science of art was made in ancient Greece by the Pythagoreans with their discovery of the exact mathematical relations between musical notes, and the connexion between these and the lengths of the string whose vibrations produce them. Thus when the lengths are in the ratio 2:1, the notes are an octave apart; in the ratio 3:2 a fifth; and so on. As Andrew Barker points out in his discussion of Greek writings on harmonic and acoustic theory, the Pythagoreans were not interested in explaining music "as such," but interested in music insofar as it manifested what they saw as an all-embracing cosmic order.

> The order found in music is a mathematical order; the principles of the coherence of a coordinated harmonic system are mathematical principles. And since these are principles that generate a perceptibly beautiful and satisfying system of organisation, perhaps it is these same mathematical relations, or some extension of them, that underlie the admirable order of the cosmos, and the order to which the human soul can aspire.

Even here, as such terms as *beautiful*, *satisfying* and *admirable* suggest, there already seems to be an underlying level of artistic sensitivity involved. The

notion of the universe as a cosmic "work of art" was to have a long history in the Western tradition, being readily adapted to a monotheistic religion, in which the artist was identified without hesitation as the Judaeo-Christian God of the Bible.

But before that development the link between music, the cosmic order and religious practice was already well established. As Barker writes, in the *De Musica* of the pseudo-Pliny, the author declares that

> it is a pious act, and one of the highest importance to mankind, to sing hymns to the gods who have given articulate voice to mankind alone. This is indicated by Homer when he says, "All day long the Achaeans sought to appease the god with song, singing a beautiful paean, chanting to far-shooting Apollo: and he heard, and rejoiced in his mind." So come now, you devotees of music, and recount to our companions who it was that first employed music, what advances in it time has discovered, and who has achieved fame, among those who have understood the science of music.

Although it would be anachronistic to try to distinguish in any rigorous way at this period between a science of music and an art of music, it is clear that the Greeks were aware of one thing: although the Pythagorean discovery of the harmonic ratios was a great discovery, it did not actually explain a great deal unless it could be linked up to the physics of sound. So the next step in explanation for the empirically minded Greeks had to be an investigation of physical causes. Although that step might be a difficult one to take, since the Greeks lacked any measuring instruments capable of tackling acoustics (which, for the same

reason, was a major weakness in Greek linguistics) it is nevertheless the step envisaged. No Greek authority on music ever suggests that the explanatory task must be abandoned at this point because mere mortals cannot hope to fathom why certain patterns of sound—but not others—are pleasing to the gods. (That, however unsatisfactory, would at least have put the problem in an artistic perspective.)

However, there certainly were Greeks who realized that studying the physics of sound was still unlikely to answer certain types of question about music. Whoever compiled Book XIX of the pseudo-Aristotelian *Problems* (possibly one of Aristotle's students) lists a number of them. Aristotle himself discusses some in Book VIII of his *Politics*, where he admits candidly: "It is not easy to determine the nature of music, or why anyone should have a knowledge of it." Aristotle offers three possibilities. One is that music affords amusement and relaxation. A second is that music "conduces to excellence": it is a practice that forms the mind in beneficial ways. The third is a combination of the first two: music is both entertaining and has a beneficial influence on the character and the soul. This last is Aristotle's preferred option.

As often, however, Aristotle's conclusion does not squarely address the original question. His underlying concern—at least in the discussion in *Politics*—concerns the justification of music as a part of education. There is no attempt to link up the supposed (psychological) *effects* of music with any physical *causes*. And somewhere in this gap is precisely where the main problems about music as an art form seem to lie.

A similar stalemate attends the attempt made by Goethe in the early 19th century to deal with the

question of colour in the visual arts. The case is interesting, because Goethe was acutely aware of his lack of qualifications in the relevant areas of science. He is constantly apologizing for it. Nevertheless, he regarded himself as having made a significant contribution not only to the study of colour in the visual arts but also to the science of colour. (This view was not shared by scientists of his own or subsequent generations.)

After studying the subject over a period of many years, Goethe eventually published his *Theory of Colours* in 1810. No victim of false modesty, he claimed:

> From the philosopher, we believe we merit thanks for having traced the phenomena of colours to their first sources, to the circumstances under which they simply appear and are, and beyond which no further explanation respecting them is possible.

Similar gratitude he thought he deserved from the artist, for

> in entering this theory from the side of painting, from the side of aesthetic colouring generally, we shall be found to have accomplished a most thankworthy office for the artist. [...] we have endeavoured to define the effects of colour as addressed at once to the eye and mind, with a view to making them more available for the purposes of art.

That artists may have appreciated his efforts more than scientists might be inferred from the fact that the *Theory of Colours* was translated into English by a Victorian painter of some distinction, Charles Eastlake, in 1840. The gaping hole in Goethe's theory from a modern scientific point of view is that it totally

ignores wavelength. Nor did Goethe suppose that before his treatise appeared the great masters of the Renaissance and their successors had been ignorant of how to deal with colour on the canvas. What he evidently thought was that their mastery was simply intuitive: they had not *understood* the principles they were unconsciously applying. This—the scientific explanation of those principles—was what Goethe's ambitious treatise sought to supply.

It is this curious notion of "scientific explanation" that makes the *Theory of Colours* interesting. What Goethe actually provides is just an abstract schema of relations between colours, from which he can derive such putative rules of harmony as "Yellow demands Red-blue," "Blue demands Red-yellow" and "Red demands Green." With Goethe, in brief, as far as explaining *art* is concerned, there appears to have been little or no progress since Aristotle. In other words, there is still no serious attempt to link cause and effect. Where Goethe differs from Aristotle is in the narrower range of effects that he treats as needing explanation. Goethe is a devotee of "I spy" art, and what strikes him as mysterious is how the artist can manage to produce on the canvas such a striking likeness to reality. "The chief art of the painter," he tells us, "is always to imitate the actual appearance of the definite hue." But as soon as we are dealing with forms of art in which that kind of imitation plays no role, any explanation based on a mimetic theory immediately loses its explanatory force. Even if the explanation were—within its own limits— convincing, what would have been explained is at best something about one particular artistic *technique*.

Where techniques are concerned, the first imperative is to distinguish between the science avail-

able to the analyst (e.g. X-ray photography, chemistry of pigments) and the science available to the artist. But the temptation to confuse analysis of techniques with providing an explanation of the art in which those techniques may be—and are—deployed has been with us at least since the Renaissance. Alberti's *De pictura* (1435) has been described as the foundational text for all subsequent Western painting. It can be read as the work which, for the first time, gave a scientific account of how to create the visual illusion of three-dimensional perspective on a two-dimensional surface. (And, some will add, if that is not science, what is?) Alberti himself was in no doubt about the dependence of competent painting upon an understanding of mathematics. Says Spencer:

> In the monocular vision proposed by Alberti the visual rays extending from the eye to the object seen assume the form of a pyramid. A painting, in Albertian terms, should be an intersection of this pyramid equidistant to the plane seen and at an established distance from the eye. Given such an approach to vision and to the work of art, geometry provides the only certainty to knowledge. By means of plane geometry based on the practice of surveying Alberti analyses the processes of vision and from this analysis draws his synthesis.

It is noteworthy that Alberti refuses to get drawn into the "scientific" question of whether the rays of light travel from the eye to the object or from the object to the eye. That, he thinks, is a matter for others to determine: it makes no difference to the artist, because the relevant geometry is the same in either case. He likewise declines to engage in "that debate of

philosophers" (*illam philosophorum disceptationem*) over what colour is. For that is likewise irrelevant to art: all that matters as far as the painter is concerned is to know what the colours are and how to use them in painting. Here, in Alberti 1435: I.9, the whole question that exercised Goethe is given short shrift. This is interesting because Alberti is no less in thrall than Goethe to the mimetic assumptions of "I spy" art. At the outset of his treatise he insists that the painter is concerned solely with the representation of what can be seen in the light (*Nam ea solum imitari studet pictorquae sub luce videantur*).

The first lesson to be drawn from this comparison is simple. Before there can be any agreement about whether scientific explanations of works of art are viable, there has to be some agreement about what kind of science is relevant and available, and to whom. Alberti clearly thought that plane geometry was the science relevant to explaining perspective drawing, but he did not see anything in current thinking about colour that was any good for explaining how to use colours. Goethe, on the other hand, thought that there was indeed a relevant theory of colour (his own) that would explain everything that needed explaining about the use of colour in art. Both positions, however, rest on certain assumptions about what the artist is trying to do (in both cases that the objective is accurate representation of what can be seen).

A no less important point is that Alberti, at least, realized that invoking the science of plane geometry takes you only as far as explaining one particular pictorial technique. For him, that is still a long way from explaining what the art of painting is. The rest of *De pictura* is devoted to describing the painter's task in

quite different terms; in particular to explaining the concept of *istoria* and what effect the *istoria* has on the viewer. Any technical mastery of perspective is subordinate to this higher objective, characteristic of Renaissance humanism. Spencer writes: "When all the requirements of Alberti's aesthetic come together in one work of art, the soul of the beholder will be captivated and he will be elevated by his experience." There is no way that absorbing the lessons from plane geometry can either bring this about, or even explain how it might be brought about.

As for Goethe, in his view

> a work of art should be the effusion of genius, the artist should evoke its substance and form from his inmost being, treat his materials with sovereign command, and make use of external influences only to accomplish his powers.

Goethe attempts no "scientific" account of how these powers can be exercised to accomplish the ends of art, any more than he feels obliged to explain how his theory of colour can be effectively applied in medicine or the dying of wool.

In 1910, Hudson Maxim, an American chemist and brother of the inventor of the Maxim machine gun, claimed to have elaborated a science of poetry. His basic idea was that words could be shown to behave in a manner similar to that of elementary units in physics and chemistry. He wrote:

> Whatever the subject of any investigation may be, whether poetry, biology, ethics or torpedo warfare, the same scientific method of procedure must be followed.

He held that, contrary to the views of

those sentimentalists who hold the principle of poetry to be something transcendental, inscrutable and incomprehensible, it requires only simple scientific method for its elucidation.

His scientific method was indeed simple. It involved taking "the complex and heterogeneous back to first principles" and then reasoning "forward from the simple to the complex." Accordingly Maxim identified the basic element of poetry as the individual speech sound.

In 2001 David Hockney published the results of research that suggested that what had hitherto been regarded as examples of artistic genius by past masters could be better explained through the unacknowledged use of certain kinds of mechanical device. He had convinced himself, from his own experience as a painter, that certain effects apparently commanded almost effortlessly by artists of high repute could not be obtained through any skill in freehand drawing or painting. Hockney claimed that from the early 15th century many Western artists had used mirrors and lenses, or a combination of the two, to create projections of the objects and scenes depicted. These projections were then used as the basis for capturing the image on paper or canvas. This, according to Hockney, resolved a great puzzle in the history of European art: why suddenly at about the time of the Renaissance artists apparently learnt to depict the visible world far more accurately than anyone had hitherto been able to do.

Hockney's claims were often met with hostility. It was said that he was accusing great artists of the past

of "cheating"—a charge of dishonesty against which they could not now defend themselves. Here I shall consider two questions only. One concerns Hockney's use of evidence. The other is whether, assuming that what he claims is true, it makes any difference to our understanding of what makes a good painting a work of art.

It could be argued that what Hockney sometimes treats as evidence for his theory is not scientific evidence at all. For example, Hockney claims that a small portrait drawing of Madame Godinot by Ingres, dating from 1829, was made with the help of a camera lucida, an optical device for artists first marketed in 1806. According to Hockney, it is possible to detect that the drawing was made in two sittings, because the head of the model is not on exactly the same scale as the shoulders, clothes and hands. This would be accounted for if the artist had moved the camera lucida between the two sittings, thus altering the magnification. The result is that the head of the portrait seems rather too big for the body. Hockney demonstrates this by producing an image in which the head is reduced by 8%, and asking the reader to note how the head now seems to fit the body more convincingly.

A sceptic might well object that, however plausible the story, this is not "scientific" evidence; for in the end a subjective judgment is called for concerning the alleged discrepancy between two parts of the drawing. And other explanations are possible than supposing that Ingres was using a camera lucida.

Underlying Hockney's "demonstration," however, is a tacit argument about artistic value. The unstated premise is that Ingres' drawing would have been a "better" portrait if the artist had managed to

remove the discrepancy: he "should have" aimed for a depiction in which the head was 8% smaller. Here once again the mimetic assumptions of "I spy" art surface: the drawing as Ingres left it is not "true to" the visible appearance of the sitter. This is the underlying artistic judgment: it has nothing to do with the techniques employed, except insofar as Ingres emerges as an artist who had not quite mastered the use of the camera lucida.

It is relevant to note at this point that in the writings of art theorists it is not uncommon to encounter a rather curious interpretation of what "science" is and does.

According to Gombrich, for instance, science is an "institution" in which "we systematically submit our reactions and responses to the scrutiny of reason." This invocation of "reason" as the backbone of science is of relatively recent origin. It was first stated overtly by Alfred North Whitehead in a presidential address to the British Association in 1916. "Science is essentially logical," Whitehead asserted. This is patently a propaganda claim, an attempt at redefinition, intended to replace a more modest and traditional view of science as careful observation of Nature. Whitehead's pronouncement was part of the campaign which enabled the sciences to achieve the commanding position in modern academic life that they now hold. If science is essentially logical, then to reject any conclusion reached by accredited scientists becomes automatically a rejection of reason itself *and on that ground alone* quite unacceptable to the academic community. But kowtowing to the fashionable rhetoric of science, as Gombrich does here, leaves it quite unclear exactly how the artist or the art critic is supposed to "submit" *artistic* "reactions and responses" to any rational scrutiny by scientists.

A major step forward in the application of science to the visual arts is often held to be the work in neurophysiology (beginning in the late 1950s and 1960s) which made it possible to explain how the traditional techniques used by artists in painting and drawing managed to achieve a recognizable "likeness" of the subject depicted, *in spite of* employing modes of depiction that seemingly omitted much of the relevant optical detail. What emerged was an account according to which the artist unwittingly reversed processes occurring in a certain natural order in the visual system of the brain. According to R. Jung:

> In sketching, the artist acts in accordance with the same visual laws, but proceeds in a direction opposite to the abstractive process of vision. He begins with the linear outlines and ends with a picture showing also the values of light and space.

The three main types of abstraction identified in representing the human body are the indication of form and contour, the indication of the articulation of the body independently of contour, and indication of movement. The first of these is indicated by outlines, the second by filling in axial lines, and the third by establishing certain relations between the axes. This corresponds—in reverse order—to the stages by which incoming visual stimuli are processed by the eye and the brain. In general terms, what occurs may be described as selection and reinforcement/exaggeration of certain features, while discarding the rest.

On this basis, the techniques adopted by certain artists stand out as unusual or innovative. For example, Dürer emerges as a pioneer in introducing hatching and

cross-hatching in woodcut, which had previously been a contoured medium, while, according to Jung, Seurat's pointillism appears designed to avoid linear contours altogether. It seems tempting to infer from this kind of analysis that certain artistic techniques are more "natural" than others when certain visual effects are being sought.

Jung draws the following cautious conclusions:

> In general, the significance and the beauty of art are only apparent to those who can see and are trained in viewing. The artist himself is not interested in the process of seeing, and lets the physiologist investigate visual mechanisms. Leonardo, who discovered certain laws of contrast vision, was unique in being both an artist and a scientist. The vain attempts of the neo-impressionists to build a theory of painting on the physiology of colour contrast show the limits of the relation between physiology and art. Modern techniques of Op Art, deliberately using optical illusions to induce stereo-patterns and movement perceptions, are confined to a narrow field.

> Although it may be useful for the artist to know some of the principles of vision and their possible applications to the visual arts, the relevance of physiological laws to the visual arts and to aesthetic values is limited. Art has a greater degree of freedom than science. Even if the scientist elucidates certain principles and limits of the visual perception of form, science cannot dictate to the artist what he should do. The frontiers of the visual arts must be set by the creative artist himself.

"Let the shoemaker stick to his last" seems to be the philosophy dictating this sombre assessment. Generalizations as wild as "The artist himself is not

interested in the process of seeing" seem to be based on ignorance; or so it might well have seemed to artists as varied as Ruskin, Magritte, Giacometti and Hockney, who all in various respects regarded the making of visual images as a way of trying to understand not only what is seen but what seeing itself is. Even Gombrich "would not deny for a moment that it can be an exciting and liberating experience to discover the true look of things by learning to draw or by studying art." Perhaps the problem is that it takes a scientist to restrict "seeing" just to what goes on mechanically in the transmission of visual images from eye to brain.

Some theorists appear to hold that qualitative judgments of all kinds can be subjected to scientific evaluation. They get very excited when, for example, it is shown by experiments that wine experts can be fooled into pronouncing one wine superior to another when exactly the same wine is presented in an expensive-looking bottle and in a cheap supermarket bottle. This is supposed to show that our judgments may be affected by all kinds of considerations that are actually irrelevant to what is ostensibly being judged. Could this be true of artistic judgments in general? One can imagine experiments analogous to the wine-tasting example conducted with paintings. Do people mistakenly detect artistic merit in a canvas that bears the signature of Picasso, or in a sculpture that has just sold for a million pounds at auction?

It may well be that they do. Doubtless judging the quality of a wine by the label on the bottle is a recipe for self-deception. But that does not mean that the door is wide open for a science that will be able tell us exactly what our evaluative judgments "really are."

Even where the wine-tasting example is concerned, it would be naive to believe that the experiment provided scientific proof that the judgments made by certain individuals were "wrong." For that presupposes that the same wine has to taste the same for everybody. On the contrary, what the experiment showed was that this was *not* a sound scientific assumption.

There is another way in which science can get a foot in the door of art theory. It was only a matter of time before a philosopher of art chanced to read Darwin and hit upon the idea of "explaining" art scientifically as a product of evolution. Denis Dutton in *The Art Instinct* (2009) proposes to develop what he calls, somewhat presumptuously, a "Darwinian aesthetics" by taking further Darwin's own half-hearted attempt to link music with sexual selection. He quotes with approval the passage in which Darwin speculates:

> All these facts with respect to music and impassioned speech become intelligible to a certain extent, if we may assume that musical tones and rhythm were used by our half-human ancestors, during the season of courtship, when animals of all kinds are excited not only by love, but by the strong passions of jealousy, rivalry, and triumph.

This, however, is Darwin at his anthropomorphizing worst. Dutton's argument might be more convincing if operatic tenors were conspicuously more successful in attracting mates than male rivals who never sang a note, or violinists had longer families than those with no interest in music at all. Furthermore, it is difficult to fit the known historical development of different forms of music into any "survival of the

fittest" scenario. As one of Dutton's critics points out, the problem with all this pseudo-Darwinism is that human artists mostly do what they do quite deliberately, whereas "intentional agents have no role in Darwinian mechanisms of natural selection."

Dutton claims that we still have the "souls" (*sic*) of our Pleistocene ancestors, with their primordial art instinct intact, presumably transmitted genetically in unbroken succession down to the present day. Even Darwin, one feels, would hardly have regarded this assumption as a scientific basis for any discussion of aesthetics.

There are scientists such as E.O. Wilson who claim to have detected the existence of "innate universals of aesthetics" and "epigenetic rules" of art.

> Artistic inspiration common to everyone in varying degree rises from the artesian wells of human nature. Its creations are meant to be delivered directly to the sensibilities of the beholder without analytic explanation. Creativity is therefore humanistic in the fullest sense. Works of enduring value are those truest to these origins. It follows that even the greatest works of art might be understood fundamentally with knowledge of the biologically evolved epigenetic rules that guided them.

Wilson even invokes the evidence of brain wave patterns, as shown in electroencephalograms, to "explain" the progressive development of Mondrian towards abstract art. He thinks that Mondrian was mistaken in supposing that he had "liberated" his painting from subservience to traditional art forms. "It stays true to the ancient hereditary ground rules that defined the human aesthetic."

Much of this is pseudo-scientific claptrap. Unsurprisingly, it fails to impress an idiocentric theorist as committed as Carey, who points out, among other things, that Wilson has not even addressed the question of why the same work of art can evoke such different reactions from different individuals. Carey is equally dismissive of attempts by neuroscientists and experimental psychologists to "explain" art by reference to the brain's responses to certain kinds of stimuli. All of these approaches are found wanting when applied to particular works and individuals' appreciations of them. For example, Zeki's attempt to explain why Vermeer's *The Music Lesson* is a great painting fails altogether to come to terms with its uniqueness as a work of art.

Carey does hold, nevertheless, the quasi-Popperian view that science can contribute to the theory of art in a negative way, i.e. by debunking bad theories. He cites as an example Clive Bell's once-fashionable theory of art as "significant form," and Bell's claim that in order to see a painting as art one must ignore its representational content. Carey writes:

> However, advances in brain science since Bell's time cast an interesting light on his recommendations. It has been found that when damage is sustained in particular areas of the brain, it results in the patient being unable to recognize objects. The world is seen only as patterns of line and colour, obeying unknown and mysterious laws, precisely as Bell required. [...] Such conditions are, of course, acutely distressing to the patient. Far from being, as Bell claims, the ultimate aim of art, they are a tragic deprivation. Those who choose to look at paintings as "significant form" remain, of course, free to do so,

but they should recognize that their aesthetic is that of the brain-damaged.

But it is far from clear, *pace* Carey, that evidence from brain damage proves anything at all about Bell's theory. According to the champions of *art brut*, insanity brings one closer to the sources of art, not further from them: it is "normality" that disguises the true nature of art. If someone had objected to Dubuffet that he was advocating an aesthetic of the insane, he might well have replied "Precisely!" A similar impasse is reached with an aesthetic of the brain-damaged. What the science of brain-damage tells us is something about abnormality, but nothing about art.

Although—surprisingly—Carey does not seem anxious to press his case this far, idiocentrism is fundamentally incompatible with the view that science can answer fundamental questions about art. For science has to deal in generalizations that hold over a given range of cases. But if art is ultimately, as the idiocentrist holds, a matter for the individual alone, it is hard to see how science can deal with it. Of what is unique there can be no science.

It would be possible to press the idiocentric case even further than Carey does, in order to accommodate the fact that, even for the individual, artistic experience is not a constant. As theorists such as Lee have argued, one *learns* to appreciate art.

The conclusion to which that leads seems inescapable. The logic of the learning curve entails that, at different points along that curve, one's judgment of what makes a particular work a work of art will vary. So it is not just that one individual's judgment will differ from another's, but that the same individual's judgment

will vary over time. Furthermore, revisiting the same work after a lapse of time, or in different circumstances, does not always yield a recognizably similar artistic experience. And that discrepancy leaves science without a foothold.

If there were ever to be a science of art, it would have to begin by rejecting the idiocentric view altogether and establishing the axiom that not *anything* can be a work of art, i.e. setting out the criteria for admission to the class of "possible works of art." No scientist has done this so far. Nor does any scientist seem anxious to do it. It is not difficult to understand this reluctance. No discipline welcomes being set an impossible task.

If a "science of art" is incompatible with idiocentrism, it is no less incompatible with conceptualism. For if the real artwork is the concept—as distinct from the artifact or its execution—that removes the study of art from the domain of science altogether. The concepts, whatever they may have been, which inspired the paintings of Rembrandt and Goya are not available for inspection in the laboratory.

Finally, nor is a "science of art" compatible with institutionalism. For if the status of a work as a work of art is determined by the relevant consensus of institutions, acting in their own interests, there is nothing for the scientist to investigate. That would be a task for the sociologist.

## Envoi

At least since Hegel, prophets of doom have been predicting the end of art. There is a chapter on "The end of art" in Arthur Danto's *The Philosophical Disenfranchisement of Art* (1986). His Mellon lectures of 1995 were published under the title *After the End of Art*. Hans Belting's *Das Ende der Kunstgeschichte?* appeared in an English translation without the question mark as *The End of the History of Art*. As if to suggest that the end of art itself might not be enough, Victor Burgin weighed in with *The End of Art Theory*.

There may well be readers who think that this book is just another addition to the sad list. If so, they have not been reading it with sufficient care and attention. In the present writer's view it is highly unlikely that in the foreseeable future painters will stop painting, or musicians stop playing music, or novelists stop writing novels. Nor is it likely that their works will no

longer be discussed. What is at issue are the terms in which that discussion will be conducted and the ensuing judgments made.

What I have argued is that the Great Debate is now dead, because it was predicated upon acceptance of a supercategory that has collapsed. It may take some time for this truth to sink in. As a result, the Debate may appear to continue for some time yet, conducted in ever shriller tones by those publicity-seekers who have a vested interest in keeping it going. But before long no one else will be paying much attention.

There is a certain amount of historical evidence about what happens to supercategories when they collapse. The supercategory of Religion is a case in point. Since its collapse in the 19th century, the main issues that would have been discussed under its auspices are now distributed under other rubrics. These rubrics include ethics, economics, politics and race. But no one any longer thinks of the issues as having a primarily religious dimension. They are discussed as aspects of the relationships between human beings, not as aspects of the relationships between God and the human race. Similarly, explanations once supported by an obsolete supercategory are no longer seriously advanced. They are replaced by other explanations. No one nowadays supposes that earthquakes are manifestations of divine anger: the religious explanation has been supplanted by a geological explanation.

History is forever trying to catch up with itself. The discourse of a defunct supercategory gradually merges into the discourses of whatever forms of inquiry supersede it. The most likely scenario for the case of Art is that artspeak will become a dialect of

mediaspeak. There are already signs of this happening, as television takes over as the main channel of information in people's lives. Then it will be up to the television moguls to decide what they will present to the public as "art" programmes, who the celebrity "artistic personality" of the year is, and so on. There will be artificially established tables of "all-time favourites." There will have to be a lot of media razzmatazz about art competitions, prizes, awards, quiz shows and public phone-ins in order to put the arts on a comparable footing with sport and other forms of mass amusement. Art "critics" will increasingly become servants of the entertainment industry, as indeed many of them already are. James Elkins has noted their frequent reluctance to pass judgment on works of art. They take refuge behind descriptions which abstain from venturing beyond supplying factual information about the work in question. This—I suggest—is because the collapse of the supercategory leaves them without any clear idea of what a "work of art" is.

But art-as-entertainment (whether entertainment on television, or radio, or in the Sunday supplements) is no longer art-as-such (as it was supposed to be under the doctrine of "*l' art pour l' art*"). The epistemological lesson to be learnt from the Great Debate is that knowledge cannot dispense with the supercategories. There are no items of "knowledge-as-such" which somehow float free of times and circumstances, i.e. of the historical conditions and circumstances of knowing. Knowing that "*X* is a work of art" is dependent on having an epistemological framework within which to situate both that claim to knowledge and its rejection. When there is no framework in place under which that can be debated, the claim itself is vacuous.

When supercategories collapse, whole structures of knowledge collapse with them. Arguments formerly valid become specious. What used to be recognized as autonomous activities now have to retreat as best they can to the shelter afforded by neighbouring enterprises.

The institutionalist will doubtless treat this admission as a triumph for institutionalism, and tell us that what is happening today is simply that the various artworlds are now merging with the mediaworld, under the auspices of a gigantic new institution far more powerful than the old institutions that supported the arts-as-arts. But that cultural takeover does not mean that the supercategory of Art is rescued and survives after all, in a kind of honourable old-age-pensioner status. On the contrary, the takeover confirms its demise.

With its demise I think that Dewey's conception of art as a mode of knowledge is no longer tenable. The current challenge for theorists of the arts is to re-articulate whatever was valuable in that conception, but in terms which do not rely on rhetorical appeal to a supercategory that can no longer support them. ■

# Notes

## Art for Art's Sake

The entry in Constant's diary is for 11 February 1804, when he was visiting Weimar. The famous formula is accompanied by a no less cryptic rider: *"Mais l'art atteint au but qu'il n'a pas."* Nietzsche's opinion is expressed in *Götzen-Dämmerung* (*Twilight of the Idols*). Gautier's defence of art for art's sake appears in the preface to his novel *Mademoiselle de Maupin*. Wilde's view is put into the mouth of Vivian in *The Decay of Lying*. Courbet's observation is to be found in the catalogue to the exhibition of his work that he mounted in Paris in 1855.

On the misunderstanding of Plato, see Collingwood in *The Principles of Art*. There is a clear statement of Aristotle's position at the beginning of his *Nichomachean Ethics*. Cicero's opinion of the arts is to be found in *De Officiis*. For the 18th-century doctrine of *beaux arts*, see the influential pre-Kantian treatise by Charles Batteux, *Les Beaux-Arts réduits à un même principe*. Kant's version of it is set out in his *Kritik der Urtheilskraft*.

Robinson had attended Schelling's lectures on art in Jena in 1802-3. These were not published until after Schelling's death, when his son included them in the *Sämmtliche Werke*. Shaw's contention about the didacticism of great art occurs in the Preface he wrote for *Pygmalion*. Baudelaire's comparison is from his essay *De l'essence du rire*. The French interest in primitive art was allegedly sparked by an African mask which came into the possession of Vlaminck in 1905. Vlaminck sold it to Derain, who showed it to Picasso and Matisse. Picasso's description of early cubism as "la peinture pour la peinture" dates from 1926. Cézanne's identification of the three basic shapes in Nature was made in a letter to Émile Bernard in 1904.

## Questions and Responses

Henry Crabb Robinson, later to become foreign correspondent of *The Times*, studied at the university of Jena from 1802 to 1805. For Schelling's views on art, see *Die Philosophie der Kunst*. On Wittgenstein's distinction between "saying" and "showing," see the entry "saying/showing" in Hans-Johann Glock, *A Wittgenstein Dictionary*.

## Art and Institutionalism

Danto's succinct characterization of the institutional theory of art is quoted from *Philosophizing Art*, and Dickie's from *Art and the Aesthetic*. Tolstoy's complaint about art critics is developed in Chapter 12 of *What is Art?* On the collusion between Berenson and Duveen, see Simpson, *The Artful Partners*. On the appointment of artists to the Tate board of trustees, see D. Lee, "A culture inbred," *The Jackdaw*, No.54, 2006.

## Art and Conceptualism

A florilegium of conceptualist pronouncements, including Sol LeWitt's, is to be found in Lippard's *Six Years*. On Hegel's distinction between *Begriff* and *Idee*, see Inwood's "Introduction" to Hegel's *Introductory Lectures on Aesthetics*. The story of Duchamp's urinal has been told many times: see Godfrey's *Conceptual Art*.

## Modernism and the Great Debate

Nadar's estimate of photography comes from his application for the legal right to use the name "Nadar" for commercial purposes: the text is given in M. Frizot and F. Ducros, *Du bon usage de la photographie*.

## Art and Anti-art

Hans Richter's book *Dada: art and anti-art* provides an excellent retrospective survey, although one obviously coloured by the author's own participation in the movement. Tzara is the source of the quotations from the Dada texts cited. The artbollocks quotation is from *The Jackdaw*, No. 78. Roger Fry's comments on Kandinsky come from a review published in *The Nation* in 1913 (reprinted in Christopher Read (ed.), *A Roger Fry Reader*. The academic quoted on "self-evidence" is Rosalind Krauss (in G. Baker (ed.), *James Coleman*).

## Art as Ambiguity

Gombrich borrows the metaphor "cryptograms on the canvas" from Winston Churchill, *Painting as a Pastime*. For a different interpretation of the "cryptogram" idea, see Dubuffet's "Notes for the well-read." The "duck/rabbit" illusion is discussed by Gombrich in *Art and Illusion* and by Wittgenstein in *Philosophical Investigations*.

## Art Inside Out

A good survey of outsider art is provided by Rhodes. A somewhat different and less flattering interpretation of the term *art brut* is offered by those art historians who draw attention to the fact that before he took up a full-time career as a painter Dubuffet was a wine merchant. The term *brut*—they suggest—is to be understood as with reference to champagne, i.e. "unsweetened." But this explanation raises more problems than it solves. For where wine-making is concerned, the analogue to raw art would be not champagne of any kind, but unfermented grape juice.

## In Defence of the Turner Prize

Serota's selection of Michael Craig-Martin's *An Oak Tree* was not a random choice of example. Craig-Martin taught in London at Goldsmiths College for many years, and a number of the "Young British Artists," including Damien Hirst, were among his pupils. The "official" defence of the Turner Prize is now Stout and Carey-Thomas's book, which proudly displays on the cover three masked engineers installing Hirst's *Mother and Child Divided* in its tank of formaldehyde.

## A Science of Art?

Alberti translated *De pictura* into Italian in the following year, and made some slight alterations to the text. These were evidently designed to make the treatise of more practical use to his fellow artists. The passage from Darwin comes from Ch. 19 of *The Descent of Man*. Dutton's critic is Martin Kemp, writing in *New Scientist*, 31 January, 2009.

# Bibliography

This bibliography includes references to texts quoted as well as a selection of other works relevant to the issues discussed.

Ades, D. *Dada and Surrealism*. London, Thames & Hudson, 1974.

Alberti, L.B. *De pictura*. 1435. Trans. J.L. Schefer, Paris, Macula, Dédale, 1992.

Apollonio, U. (ed.) *Futurist Manifestos*. Trans. R. Brain, R.W. Flint, J.C. Higgit and C. Tisdall, London, Thames & Hudson, 1973.

Atkins, R. *Artspoke. A Guide to Modern Ideas, Movements and Buzzwords, 1848-1944*. New York, Abbeville, 1993.

Baker, G. (ed.) *James Coleman*. October Files 5, Cambridge, MA, MIT Press, 2003.

Barker, A. (ed.) *Greek Musical Writings I: The Musician and his Art*. Cambridge, Cambridge University Press, 1984.

... *Greek Musical Writings II: Harmonic and Acoustic Theory*. Cambridge, Cambridge University Press, 1987.

Baudelaire, Ch. *Écrits sur l' art*. Ed. F. Moulinat, Paris, Livre de Poche, 1999.

Bell, C. *Art*. 1914. ed. J.B. Bullen, Oxford, Oxford University Press, 1987.

Benjamin, W. "L' oeuvre d' art à l' époque de sa reproduction mécanisée." 1936. In W. Benjamin. *Écrits français*, Ed. J-M. Monnoyer, Paris, Gallimard, 1991, pp.140-192.

Belting, H. *The End of Art History*. Trans. C.S. Wood, Chicago, University of Chicago Press, 1987.

Berenson, B. *Aesthetics and History*. London, Constable, 1950.

Berger, J. *Ways of Seeing*. London, BBC/Harmondsworth, Penguin, 1972.

Bujic, B. "Aesthetics of music." In D. Arnold (Ed.), *The New Oxford Companion to Music*. Oxford, Oxford University Press, 1983, pp.20-24.

Burgin, V. *The End of Art Theory. Criticism and Postmodernity*. London, Macmillan, 1986.

Carey, J. *The Intellectuals and the Masses*. London, Faber & Faber, 1992.

... *What Good are the Arts?* London, Faber & Faber, 2005.

Churchill, W.S. *Painting as a Pastime*. London, 1948.

Clark, T.J. *Image of the People: Gustave Courbet and the 1848 Revolution*. Berkeley, University of California Press, 1973.

Collingwood, R.G. *Outlines of a Philosophy of Art*. Oxford, Clarendon, 1925.

... *The Principles of Art*. Oxford, Clarendon, 1938.

Danto, A.C. *The Philosophical Disenfranchisement of Art*. New York, Columbia University Press, 1986.

... *After the End of Art. Contemporary Art and the Pale of History*. Princeton, Princeton University Press, 1997.

... *Philosophizing Art*. Berkeley, University of California Press, 1999.

Dewey, J. *Art as Experience*. New York, Minton, Balch, 1934. Page references are to the 1980 reprint by Putnam's, New York.

Dickie, G. *Art and the Aesthetic. An Institutional Analysis*. Ithaca, Cornell University Press, 1974.

Dubuffet, J. "Notes for the well-read." 1945. Trans. J. Neugroschel, in M. Glimcher 1987: 67-86.

... "Art brut preferred to the cultural arts." 1947. Trans. J. Neugroschel, in M. Glimcher 1987: 101-104.

... "Anticultural positions." 1951. Repr. in V. da Costa and F. Hergott (eds), J. Dubuffet. *Works, writings, and interviews*. Barcelona, Ediciones Poligrafa, 2006, pp.114-119.

Dutton, D. *The Art Instinct. Beauty, Pleasure and Human Evolution*. New York, Bloomsbury, 2009.

Elkins, J. *What Happened to Art Criticism?* Chicago, Prickly Paradigm Press, 2003.

Fischer, E. *The Necessity of Art. A Marxist Approach*. Trans. A. Bostock, Harmondsworth, Penguin, 1963.

Fong, K. "Don't knock knowledge." *Times Higher Education*, July 18, 2008, p.29.

Forster, E.M. *Two Cheers for Democracy*. New York, Harcourt, Brace & World, 1951.

Foucault, M. *Ceci n'est pas une pipe*. Paris, Fata Morgana, 1973.

Freeland, C. *But is it art?* Oxford, Oxford University Press, 2001.

Frizot, M. and Ducros, F. *Du bon usage de la photographie*. Paris, Centre National de la Photographie, 1987.

Glimcher, M. (Ed.) Jean Dubuffet. *Towards an Alternative Reality*. New York, Pace, 1987.

Glock, H-J. *A Wittgenstein Dictionary*. Oxford, Blackwell, 1996.

Godfrey, T. *Conceptual Art*. London, Phaidon, 1998.

Goethe, J.W. von. *Theory of Colours*. 1810. Trans. C.L. Eastlake, ed. D.B. Judd, Cambridge, MA, MIT Press, 1970.

Gombrich, E.H. "Illusion and art." In R.L. Gregory and E.H. Gombrich (eds), *Illusion in Nature and Art*, London, Duckworth, 1973, pp.193-243.

... *The Image and the Eye*. London, Phaidon, 1982.

... *Art and Illusion. A Study in the Psychology of Pictorial Representation*. 6th edn, London, Phaidon, 2002.

Harris, R. *The Necessity of Artspeak*. London, Continuum, 2003.

Harrison, C. and Wood, P. (eds) *Art in Theory 1900-1990*. Oxford, Blackwell, 1992.

Harrison, C., Wood, P. and Gaiger, J. (eds) *Art in Theory 1815-1900*. Oxford, Blackwell, 1998.

Hegel, G.F.W. *Introductory Lectures on Aesthetics*. 1835. trans. B. Bosanquet, ed. M. Inwood, London, Penguin, 1993.

Hockney, D. *Secret Knowledge. Rediscovering the lost techniques of the Old Masters*. London, Thames & Hudson, 2001.

Inwood, M. "Introduction" to Hegel 1835: xi-xxxvi., 1993.

Jung. R. "Art and visual abstraction." In R.L. Gregory (ed.), *The Oxford Companion to the Mind*, Oxford, Oxford University Press, pp.40-47, 1987.

Kandinsky, W. *Über das Geistige in der Kunst*. 1911. Trans. M.T.H. Sadler, London, Constable, 1914. Repr. New York, Dover, 1977 under the title *Concerning the Spiritual in Art*. Page references to the reprint.

Kennedy, H. and Knoblauch, K. "Imagery, art and biological aspects of consciousness," *Word & Image* 21, pp.124-135, 2005.

Kreitler, H. and Kreitler, S. *Psychology of the Arts*. Durham, NC, Duke University Press, 1972.

Lee, D. "A culture inbred." *The Jackdaw*, No.54, pp.1-7, 2006.

... "What good is art?" *The Jackdaw*, No.42, pp.1-5, 2004.

Lippard, L. *Six Years*. Berkeley, University of California Press, 1973.

Marinetti, F.T. in *Le Figaro*. Paris, Feb. 20, 1909. Trans. R.W. Flint, "The founding and manifesto of futurism 1909," in Apollonio 1973: 19-24.

Proudhon, P.J. *Du principe de l' art et de sa destination sociale*. Paris, Garnier Frères, 1865.

Ramachandran, V.S. and Hirstein, W. "The science of art: a neurological theory of aesthetic experience," *Journal of Consciousness Studies*, 6: 6-7, 1999.

Read, C. (ed.) *A Roger Fry Reader*. Chicago, University of Chicago Press, 1996.

Read, H. *Education Through Art*. 3rd edn. London, Faber & Faber, 1956.

Rhodes, C. *Outsider Art: Spontaneous Alternatives*. London, Thames & Hudson, 2000.

Richter, H. *Dada: art and anti-art*. Trans. D. Britt, London, Thames & Hudson, 1965.

Saussure, F. de. *Cours de linguistique générale*. 2nd edn. Paris, Payot, 1922.

Schelling, F.W.J. *Die Philosophie der Kunst*. 1859. Trans. D.W. Stott, *The Philosophy of Art*, Minneapolis, University of Minnesota Press, 1989.

Serota, N. "Who's Afraid of Modern Art?" London, BBC, 2000. http://www.bbc.co.uk/artzone/dimbleby/text_only.shtml

Simpson, C. *The Artful Partners*. London, Unwin, 1988.

Smets, G. *Aesthetic Judgment and Arousal: An Experimental Contribution to Psycho-aesthetics*. Leuven, Leuven University Press, 1973.

Spencer, J.R. "Introduction" to Leon Battista Alberti, *On Painting*, rev. edn, New Haven, Yale University Press, 1966.

Stout, K. and Carey-Thomas, L. (Eds) *The Turner Prize and British Art*. London, Tate, 2007.

Sylvester, D. *Magritte*. London, Arts Council of Great Britain, 1969.

Thompson, D. *The $12 Million Stuffed Shark*, London, Aurum, 2008.

Tolstoy, A.N. *What is Art?* 1898. Trans. A. Maude, Ed. W. Gareth Jones, Bristol, Bristol Classical Press, 1994.

Tzara, T. *Seven Dada Manifestos and Lampisteries*. Trans. B. Wright, London, Calder, 1992.

Wilson, E.O. *Consilience. The Unity of Knowledge*. London, Little, Brown, 1998.

Wittgenstein, L. *Tractatus Logico-Philosophicus*. Trans C.K. Ogden, London, Routledge & Kegan Paul, 1922.

... *Philosophical Investigations*. Ed. G.E.M. Anscome and R. Rhees, 3rd edn, Oxford, Blackwell, 2001.

Wollheim, R. *Art and its Objects*. London, Pelican, 1970.

Zeki, S. *Inner Vision: An Exploration of Art and the Brain*. Oxford, Oxford University Press, 1999.

Also available from Prickly Paradigm Press:

Paradigm 1    *Waiting for Foucault, Still*
              Marshall Sahlins

Paradigm 2    *War of the Worlds: What about Peace?*
              Bruno Latour

Paradigm 3    *Against Bosses, Against Oligarchies: A Conversation with*
              *Richard Rorty*
              Richard Rorty, Derek Nystrom, and Kent Puckett

Paradigm 4    *The Secret Sins of Economics*
              Deirdre McCloskey

Paradigm 5    *New Consensus for Old: Cultural Studies from Left to Right*
              Thomas Frank

Paradigm 6    *Talking Politics: The Substance of Style from Abe to "W"*
              Michael Silverstein

Paradigm 7    *Revolt of the Masscult*
              Chris Lehmann

Paradigm 8    *The Companion Species Manifesto: Dogs, People, and*
              *Significant Otherness*
              Donna Haraway

Paradigm 9    *9/12: New York After*
              Eliot Weinberger

Paradigm 10   *On the Edges of Anthropology (Interviews)*
              James Clifford

Paradigm 11   *The Thanksgiving Turkey Pardon, the Death of Teddy's Bear,*
              *and the Sovereign Exception of Guantánamo*
              Magnus Fiskesjö

Paradigm 12   *The Root of Roots: Or, How Afro-American Anthropology*
              *Got its Start*
              Richard Price and Sally Price

Paradigm 13   *What Happened to Art Criticism?*
              James Elkins

Paradigm 14   *Fragments of an Anarchist Anthropology*
              David Graeber

*continued*

Paradigm 15 *Enemies of Promise: Publishing, Perishing, and the Eclipse of Scholarship*
Lindsay Waters

Paradigm 16 *The Empire's New Clothes: Paradigm Lost, and Regained*
Harry Harootunian

Paradigm 17 *Intellectual Complicity: The State and Its Destructions*
Bruce Kapferer

Paradigm 18 *The Hitman's Dilemma: Or, Business, Personal and Impersonal*
Keith Hart

Paradigm 19 *The Law in Shambles*
Thomas Geoghegan

Paradigm 20 *The Stock Ticker and the Superjumbo: How The Democrats Can Once Again Become America's Dominant Political Party*
Rick Perlstein

Paradigm 21 *Museum, Inc.: Inside the Global Art World*
Paul Werner

Paradigm 22 *Neo-Liberal Genetics: The Myths and Moral Tales of Evolutionary Psychology*
Susan McKinnon

Paradigm 23 *Phantom Calls: Race and the Globalization of the NBA*
Grant Farred

Paradigm 24 *The Turn of the Native*
Eduardo Viveiros de Castro, Flávio Gordon, and Francisco Araújo

Paradigm 25 *The American Game: Capitalism, Decolonization, World Domination, and Baseball*
John D. Kelly

Paradigm 26 *"Culture" and Culture: Traditional Knowledge and Intellectual Rights*
Manuela Carneiro da Cunha

Paradigm 27 *Reading* Legitimation Crisis *in Tehran: Iran and the Future of Liberalism*
Danny Postel

Paradigm 28  *Anti-Semitism and Islamophobia: Hatreds Old and New in Europe*
Matti Bunzl

Paradigm 29  *Neomedievalism, Neoconservatism, and the War on Terror*
Bruce Holsinger

Paradigm 30  *Understanding Media: A Popular Philosophy*
Dominic Boyer

Paradigm 31  *Pasta and Pizza*
Franco La Cecla

Paradigm 32  *The Western Illusion of Human Nature: With Reflections on the Long History of Hierarchy, Equality, and the Sublimation of Anarchy in the West, and Comparative Notes on Other Conceptions of the Human Condition*
Marshall Sahlins

Paradigm 33  *Time and Human Language Now*
Jonathan Boyarin and Martin Land

Paradigm 34  *American Counterinsurgency: Human Science and the Human Terrain*
Roberto J. González

Paradigm 35  *The Counter-Counterinsurgency Manual: Or, Notes on Demilitarizing American Society*
Network of Concerned Anthropologists

Paradigm 36  *Are the Humanities Inconsequent? Interpreting Marx's Riddle of the Dog*
Jerome McGann

Paradigm 37  *The Science of Passionate Interests: An Introduction to Gabriel Tarde's Economic Anthropology*
Bruno Latour and Vincent Antonin Lépinay

Paradigm 38  *Pacification and its Discontents*
Kurt Jacobsen

Paradigm 39  *An Anthropological Theory of the Corporation*
Ira Bashkow

Paradigm 40  *The Great Debate About Art*
Roy Harris